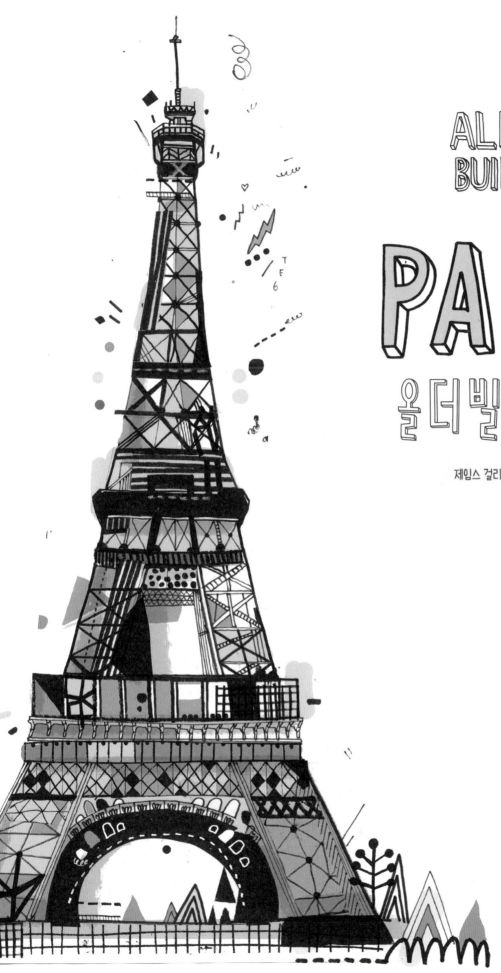

# ALL THE BUILDINGS* IN PARIS

# 올 더 빌딩스 인 파리

제임스 걸리버 핸콕 지음 | 김문주 옮김

책/발전소

# 파리의 모든 건물
## 낭만의 도시, 파리를 걷다

나는 그저 '파리'라는 단어를 입에 올리기만 했을 뿐인데 온 세상 사람은 수없이 강렬한 감정과 심미적인 기억을 떠올린다. 이 도시가 함축하는 바는 너무나 보편적이어서 내가 종이와 연필을 꺼낼 필요도 없을 정도이다. '파리'라는 말을 들은 직후에 머릿속에는 고전적인 음식부터 예술계 거장들, 패션, 그리고 순수한 낭만 그 자체에 이르기까지 모든 것이 자리한다. 한 도시가 대중문화에서 그토록 강한 상징성을 소유한다는 것은 정말로 놀라운 일이다.

그래서 파리가 품은 모든 진부한 표현을 멀리하기도 쉽지 않다. 파리를 처음 방문했을 때 이 도시를 진정으로 경험하려면 어떻게 해야 할지 고민했다. 나는 그저 여기저기 돌아다니며 사진을 찍고 초콜릿 크루아상을 먹으면서 장 폴 사르트르나 피카소와 함께 카페에서 노닥거리며 자랐어야 했다고 한탄이나 하고 싶지 않았다. 아주 뻔한 장소를 방문하는 일은 불만을 자아낸다. 파리는 지나치게 유명해서 사람들은 직접 가보기도 전에 머릿속에 미리 만든 지도를 저장해놓을 정도이다. 그렇다면 가장 중요한 것은 그 장소를 스스로 재구성하는 일이다. 그래서 나는 현실과 상상을 분리하기 위해 그림을 그린다.

나는 어떤 장소와 그에 연관된 기억을 좀 더 개인적으로 이해하길 바라는 한편 그 단편적인 관찰에서 되도록 많은 것을 쥐어짜 내기 위해 그림을 작업한다. 이 작업을 제대로 해낼 때면 기분은 마치 그 장소와 오래도록 포옹하는 것만 같다. 나는 주로 주변의 건축물을 중요하게 생각한다. 건축물은 경험과 기억을 함께 아우르는 장소를 구성하는 기본 뼈대이며, 시대를 관통하는 과묵한 관찰자이기 때문이다. 그리고 이 관찰자는 순간의 장면과 격렬함과 낭만의 티끌을 그러모은다.

죽은 것만 같은 사물이 단단히 서 있는 벽 사이에 그토록 낭만적인 상징을 품는다는 것은 놀라운 일이다. 우리는 그 안에 엄청난 역사와 의미를 채워 넣는다. 그리고 이 건축물은 생명을 가진다.

호주 시드니에서 시작해 영국 런던을 거쳐 대륙과 대륙을 넘나드는

어마어마한 여행의 끄트머리는 프랑스 파리였다. 친숙한 동화 속으로 발을 내딛는 것 같았다. 언어, 음식, 거리, 센강, 건물, 루브르 박물관에 걸린 그림은 내가 그 옛날 집에서 읽던 소설 속 세계였기에 친근했다. 건축물을 그림으로 표현하는 프로젝트를 행하는 이유는 그 도시를 올바르게 이해하는 한편 환상 속에 머무는 것만 같은 감각에서 완전히 벗어나기 위해서이다. 어느 도시에서 겪은 내 경험을 하나하나 그려낼

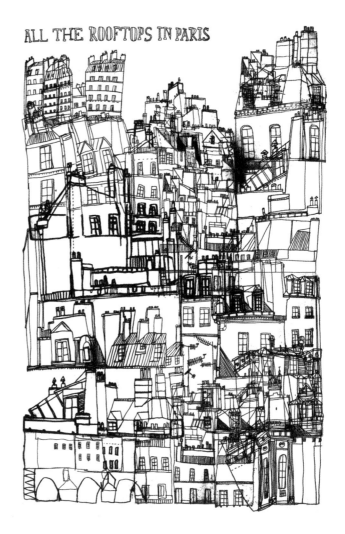

ALL THE ROOFTOPS IN PARIS

때면 좀 더 효과적으로 그 도시를 이해하고 기록할 수 있다. 잠시 멈춰 주위를 둘러보아야 그곳을 진정으로 알게 된다. 꼭대기에서 맨 밑바닥까지 소소한 부분을 모두 훑어보지 못한 모습을 그저 사진으로만 남겼다면, 씩 웃는 괴물 석상이나 특정한 거리에서 풍기는 냄새는 내 그림만큼 나를 휘감지 못했을 것이다. 어떤 장소에서 시간을 보낼 때 그림은 두고두고 음미할 매우 풍부한 추억을 만들어준다. 그리고 일기 같은 그림으로 추억은 되살아난다.

첫 방문 이후 파리로 돌아와 한동안 머물 기회를 누렸다. 나는 마레지구 근처 파리국제예술공동체로 초대받았다. 마법 같은 시간이었다. 당시 여자 친구(현 아내)와 나는 옆집 오페라 가수의 노랫소리를 들으며 잠에서 깨어났다. 그리고 나면 우리가 좋아하는 시장에 가서 그릴에 구울 송어 한 마리와 신선한 딸기, 그리고 너무나 고릿해서 진통제를 씹는 것 같은 블루치즈를 샀다.

내가 그곳에서 머무는 동안 그린 가장 중요한 그림은 널따랗게 퍼진 '파리의 모든 지붕 꼭대기'이다. 처음으로 한 도시에서 좋아하는 것을 기록하려고 시도한 그림이다. 나는 언젠가 사크레쾨르 대성당 꼭대기에 앉아 모든 지붕을 바라보았다. 그리고 잘 지어진 건축물이 켜켜이 포개지고, 제멋대로 솟아오른 굴뚝과 타일과 작은 창문이 둥글게 모인 모습에 압도당했다. 그래서 나는 그림을 그리기 시작했다. 그 후 거리를 걸어 다닐 때마다 하늘을 올려다보며 건물 맨 위편의 그 놀랍고도 다양한 모습을 바라보기 시작했다. 나는 이 모두를 간직하고 싶었다. 그렇게 내 욕망이 되살아났다. 내 눈에 들어온 것은 이 건축물이 매혹적인 조각 누비이불처럼 모두 한자리에 모여 오랜 친구같이 정담을 나누는 모습이었다.

나에게 파리의 건축은 음식의 경험과 떼려야 뗄 수 없는 관계이다. 내가 맛본 최고의 치즈가 진열된 선반 위로 곱게 아치를 그리며 떨어지는 차양, 난생처음 먹는 레몬 설탕 크레이프에 그만 정신을 놓아버릴 것 같던 작고 어두컴컴한 크레이프 가게 같은 식이다. 게다가 그 어디서도 다시 찾을 수 없을 비싼 빵집도 있었다. 내 인생을 송두리째 바꿔놓은 초콜릿 빵과 바게트를 파는 곳이었다. 어느 빵집이 그 맛을 따라갈 수 있으랴. 특히 내가 머물던 집에서 길모퉁이를 돌면 생애 최고의 초콜릿 케이크를 파는 가게가 나타나던 기억도 난다. 그 초콜릿 케이크를 한입 베어 물던 순간은 마치 영화, 아니 거의 종교와도 같았다. 온몸의 감각이 활짝 열리면서 나를 둘러싼 모든 세상이 구석구석 눈으로 들어왔다. 케이크 가게가 있던 건물과 건물 앞으로 난 길, 바로 옆에 붙어 있던 평범한 슈퍼마켓, 케이크를 내어주던 무뚝뚝한 여인, 그

리고 그 케이크를 더는 만들지 않는 것 같은 눈치에 솟아나던 완연한 실망감을 나는 절대 못 잊는다. 그림은 눈 깜짝할 사이에 흘러가 버리는 시적인 순간을 붙잡는 방법이다. 나에게는 현재의 순수한 경험이 몸에서 흘러나와 오직 그 찰나에만 가능한 방식으로 종이 위에 입혀지는 것과 같다. 같은 순간은 절대 되돌아오지 않는다. 그리고 그림을 통해 나는 가장 효과적으로 이를 기록할 수 있다.

다양한 감각이 어떻게 그토록 강렬한 추억을 형성할 수 있는지 놀랍기만 하다. 오래오래 남는 기억은 우연히 만들어지는 경우가 대부분이다. 아무 기대 없이 한 입 떠 넣은 케이크, 아니면 지나가다 훅 올라오는 치즈 냄새 같은 것이다. 그림은 한결같이 그 시간을 기억하도록 해준다. 또한 나를 둘러싼, 그리고 당신 앞에 나타난 것을 잠시 멈춰 서서 바라보고 교감하도록 한다. 그림은 눈과 뇌 그리고 손가락을 거친 현실이 종이 위에 내려앉은 작품이다. 온몸은 일기를 기록하듯 그림을 그리는 순간에 몰두하고 영향을 끼친다. 당신이 앉은 그 의자도 그림 안으로 들어간다. 돌길 위를 또각거리며 걸어가는 하이힐 소리도 마찬가지이다. 그러니까 나는 결국 그림을 통해 그 장소와 사랑에 빠진다.

나는 당신에게 그림을 통해 장소를 탐험해보라고 권하고 싶다. 더 자주 멈춰서 바라볼수록 더 많은 것을 보고 경험할 수 있다. 이쯤에서 건강한 집착은 말할 것도 없이 중요하다. 동일한 대상을 반복해서 볼 때 다양한 것을 알 수 있다. 그리고 이는 가능한 한 많은 것을 포용하도록 당신을 자극한다. 파리의 모든 것을 보지 못한다는 불안감은 모든 건축물을 그리려는 시도 뒤에 숨은 동력이었다. 그리고 어느 단계에 이르면 이 신성한 장소가 보여주는 모든 것을 경험하리라는 나 자신과의 약속이기도 했다. 나는 그것이 불가능하거나 우스꽝스럽더라도 이 프로젝트가 지닌 무한한 본질에 안심한다는 것을 깨달았다.

나는 언제나 그림을 그린다. 그러므로 나는 언제나 본다. 방문했던 수많은 장소와 마찬가지로 파리 역시 언제나 나와 함께할 것이다. 파리가 어떻게 움직이는지 가만히 바라보고 관찰하는 시간을 가졌으므로. 나를 둘러싼 모든 것을 표현하려는 집착 덕분에 언제나 즐겁다. 당신도 이 책으로 도시의 건물을 직접 색칠해보며 파리를 느끼고 여행을 추억하길 바란다.

6 PARVIS
NOTRE-DAME

# NOTRE-DAME
(OUR LADY)

ONE OF THE FINEST
EXAMPLES OF FRENCH
GOTHIC ARCHITECTURE.

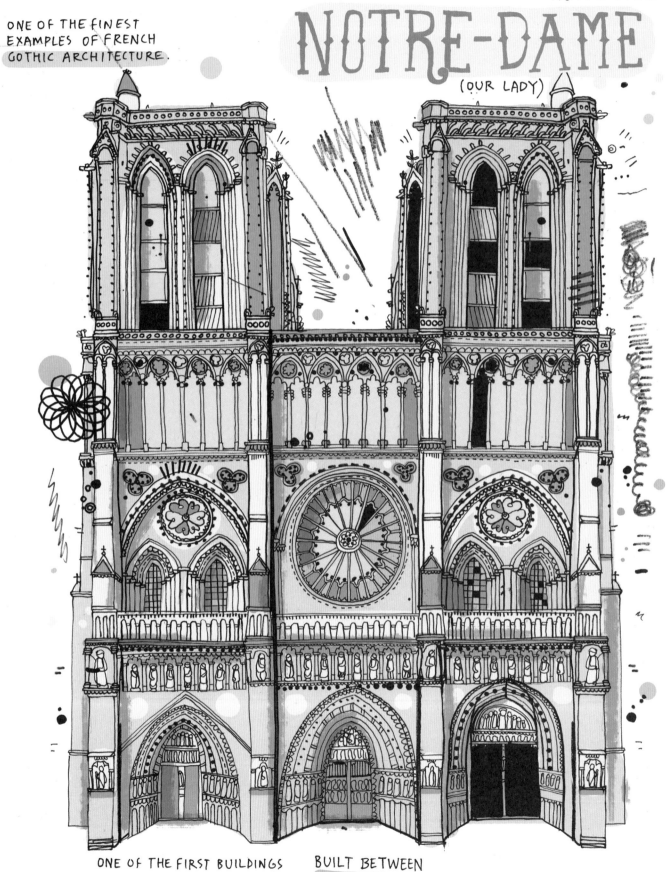

ONE OF THE FIRST BUILDINGS
TO USE FLYING BUTTRESSES

BUILT BETWEEN
1160—1345

ONE OF THE FINEST
EXAMPLES OF FRENCH
GOTHIC ARCHITECTURE.

NOTRE-DAME

(OUR LADY)

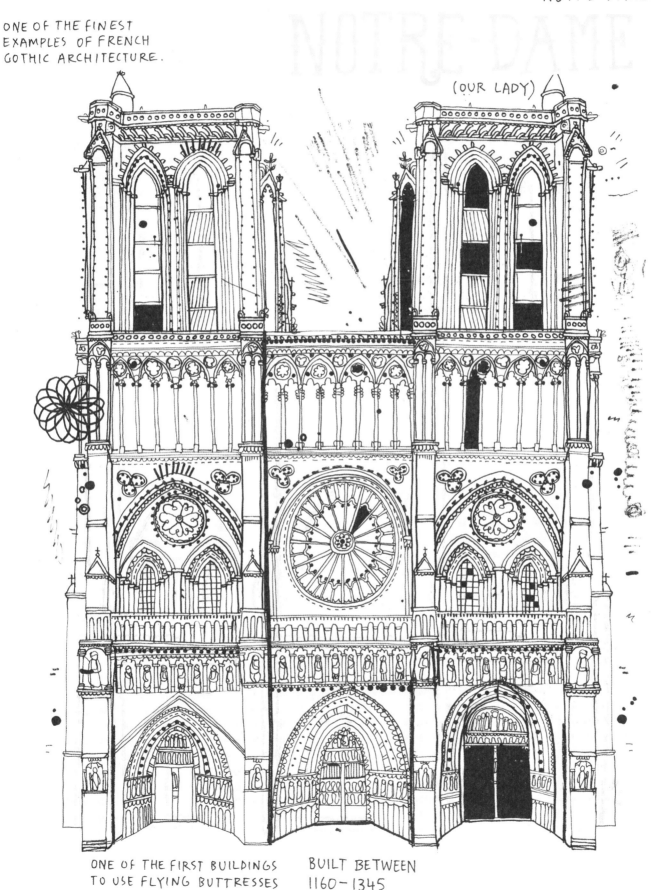

ONE OF THE FIRST BUILDINGS
TO USE FLYING BUTTRESSES

BUILT BETWEEN
1160-1345

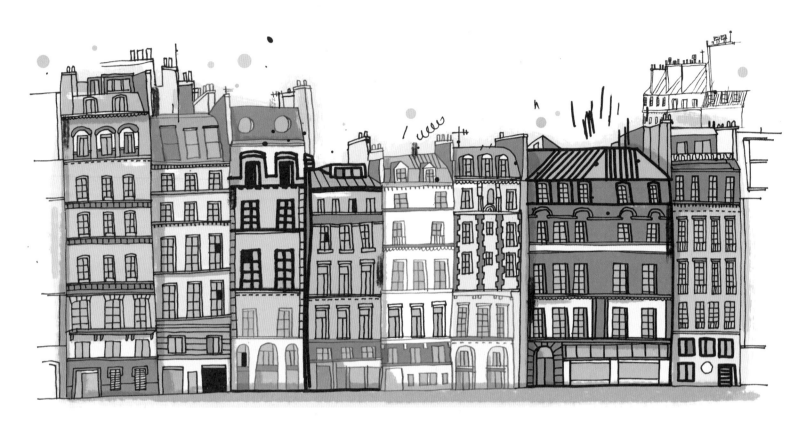

# ÎLE DE LA CITÉ

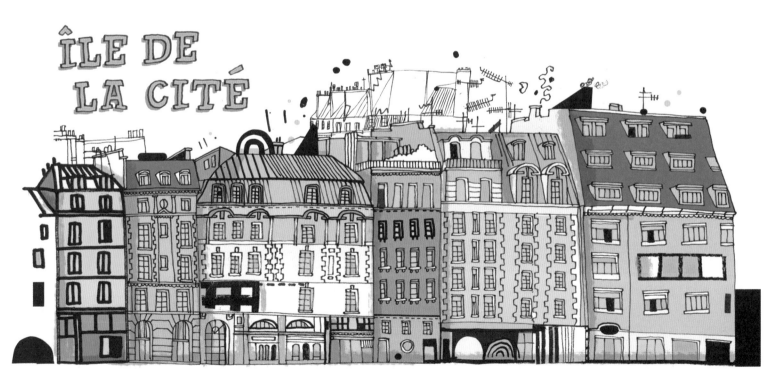

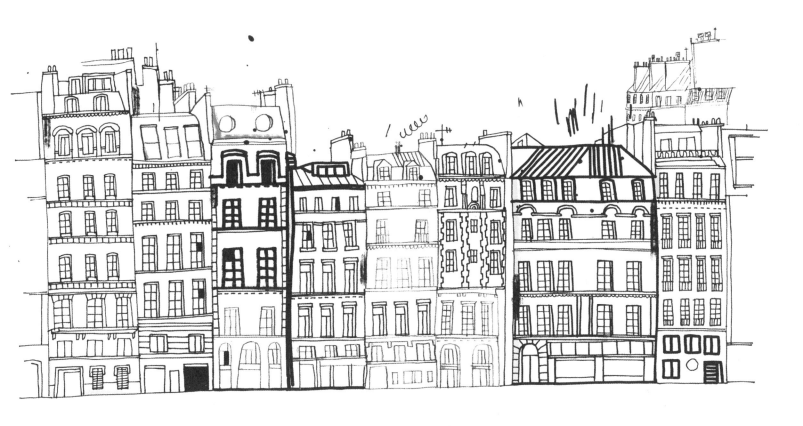

# ÎLE DE LA CITÉ

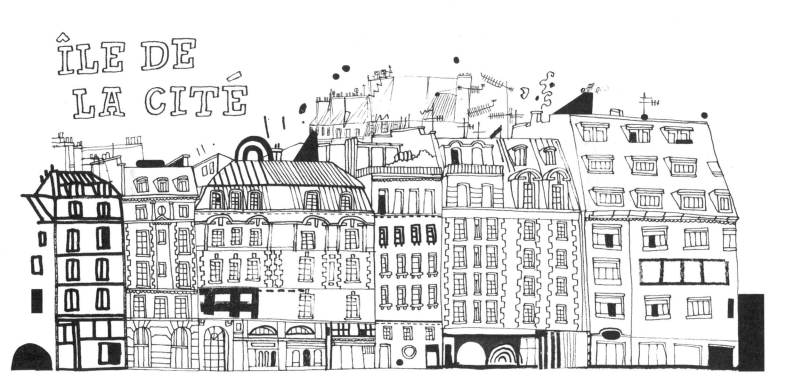

IT WAS THE RESIDENCE
OF THE KING OF
FRANCE FROM THE
6TH–14TH CENTURIES.
DURING THE
REVOLUTION IT WAS
A COURTHOUSE AND
PRISON.

TRACES OF HUMAN
HABITATION HAVE BEEN
FOUND AND DATED
TO 5000 BC.

PALAIS
DE LA CITÉ

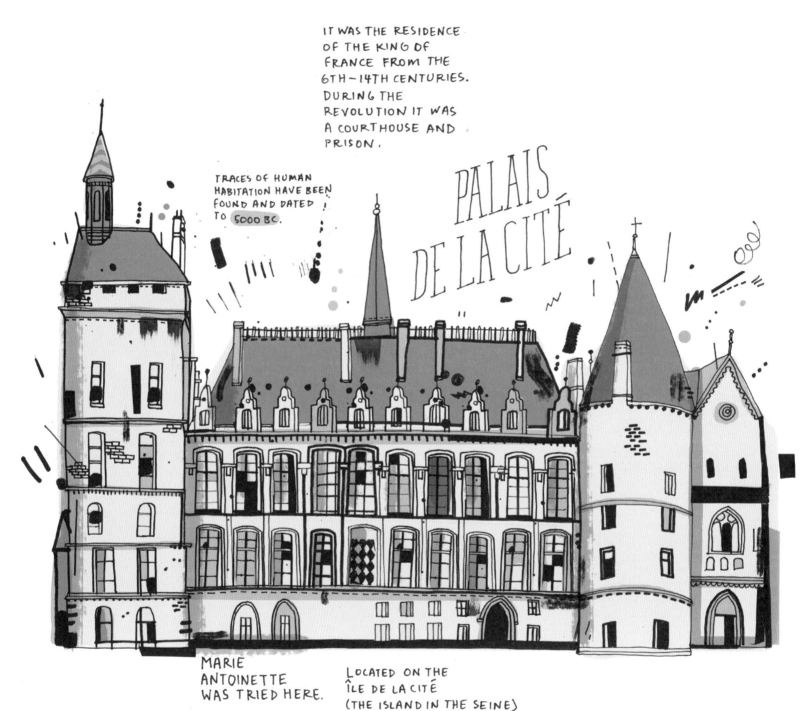

MARIE
ANTOINETTE
WAS TRIED HERE.

LOCATED ON THE
ÎLE DE LA CITÉ
(THE ISLAND IN THE SEINE)

IT WAS THE RESIDENCE
OF THE KING OF
FRANCE FROM THE
6TH—14TH CENTURIES.
DURING THE
REVOLUTION IT WAS
A COURTHOUSE AND
PRISON.

TRACES OF HUMAN
HABITATION HAVE BEEN
FOUND AND DATED
TO 5000 BC.

PALAIS
DE LA CITÉ

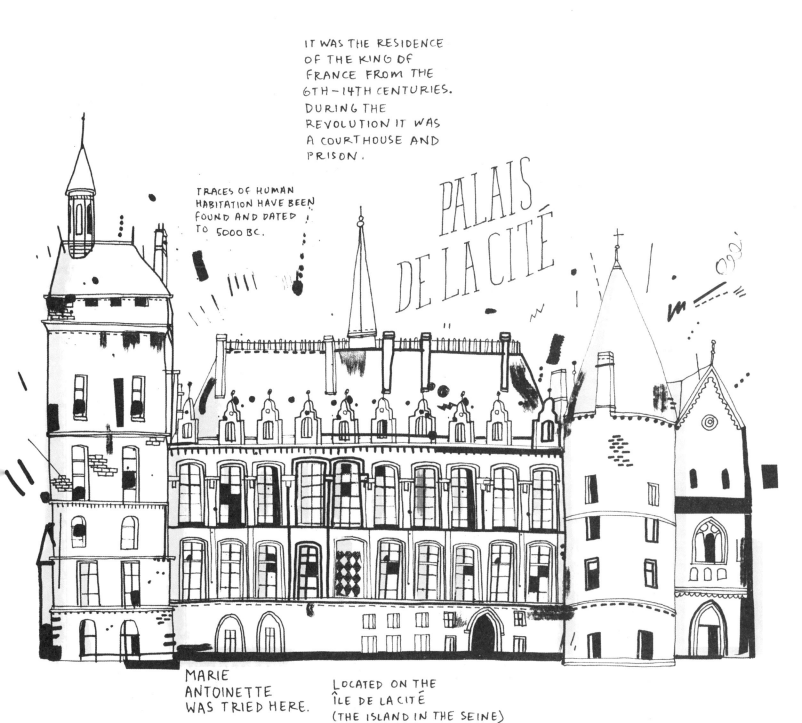

MARIE
ANTOINETTE
WAS TRIED HERE.

LOCATED ON THE
ÎLE DE LA CITÉ
(THE ISLAND IN THE SEINE)

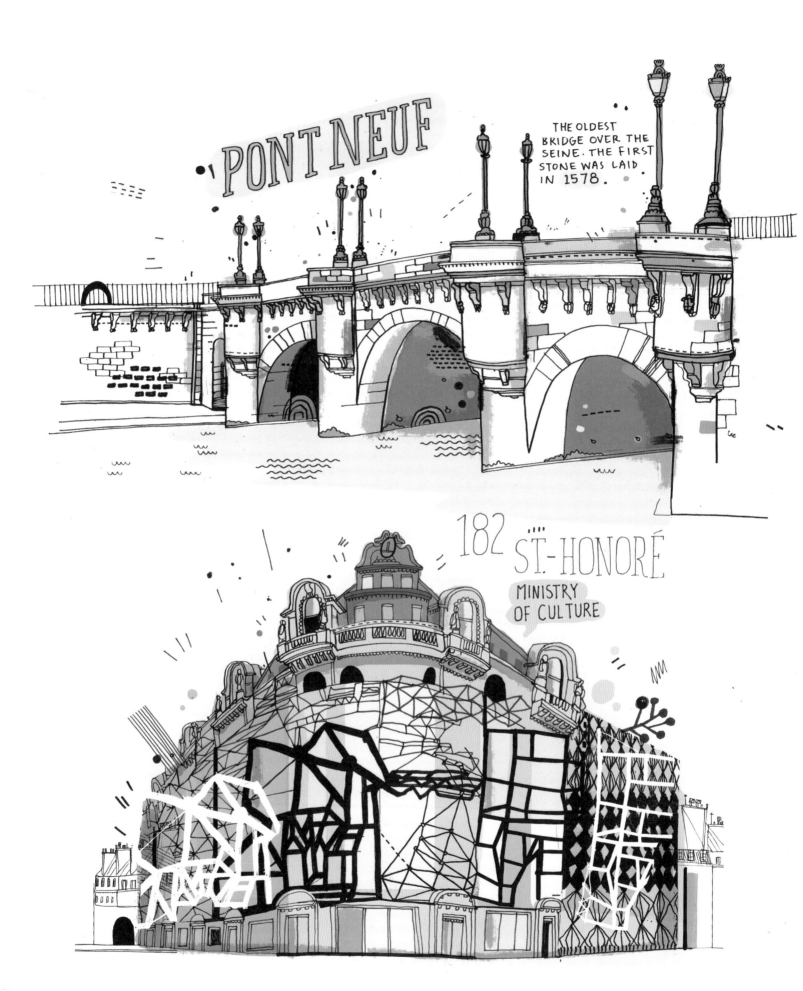

PONT NEUF

THE OLDEST
BRIDGE OVER THE
SEINE. THE FIRST
STONE WAS LAID
IN 1578.

182 ST.-HONORÉ
MINISTRY
OF CULTURE

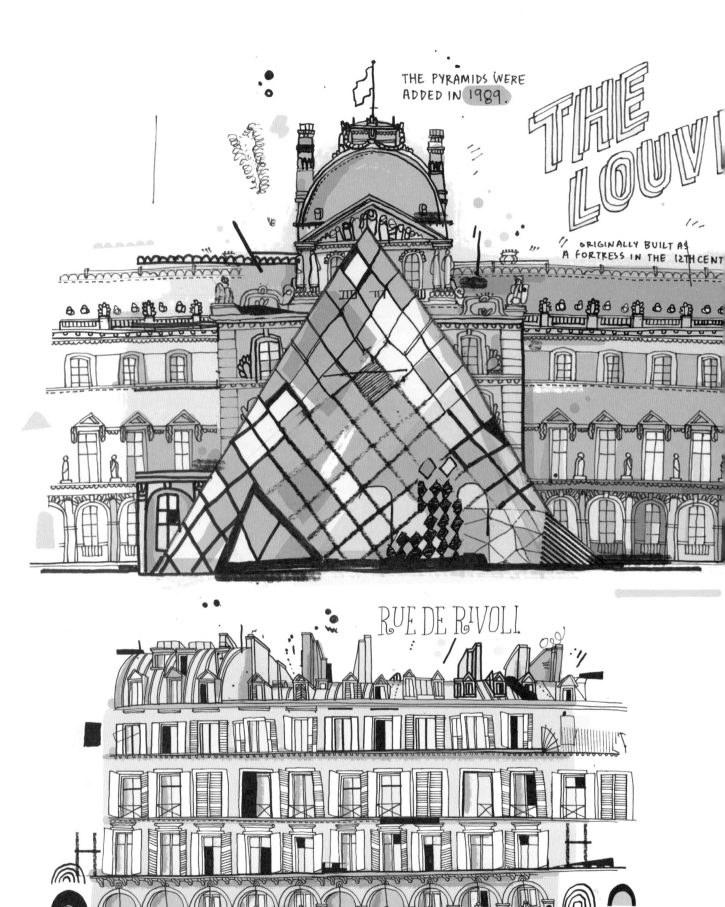

THE PYRAMIDS WERE ADDED IN 1989.

THE LOUVRE

ORIGINALLY BUILT AS A FORTRESS IN THE 12TH CENT

RUE DE RIVOLI

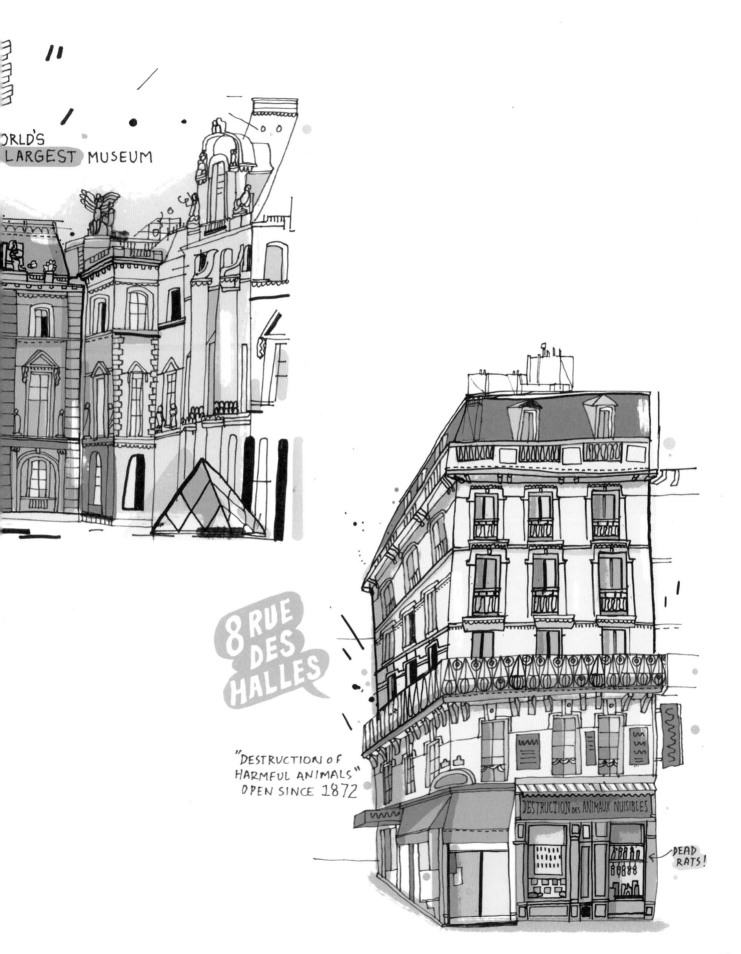

WORLD'S LARGEST MUSEUM

8 RUE DES HALLES

"DESTRUCTION OF HARMFUL ANIMALS" OPEN SINCE 1872

DESTRUCTION des ANIMAUX NUISIBLES

DEAD RATS!

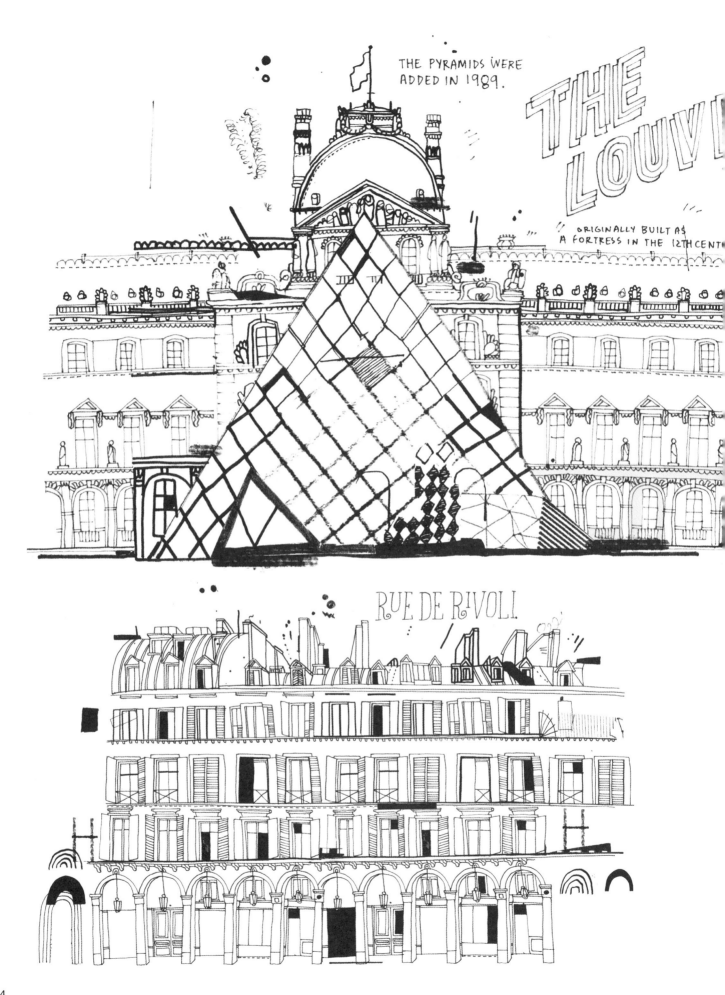

THE PYRAMIDS WERE ADDED IN 1989.

THE LOUV[RE]

ORIGINALLY BUILT AS A FORTRESS IN THE 12TH CENT[URY]

RUE DE RIVOLI

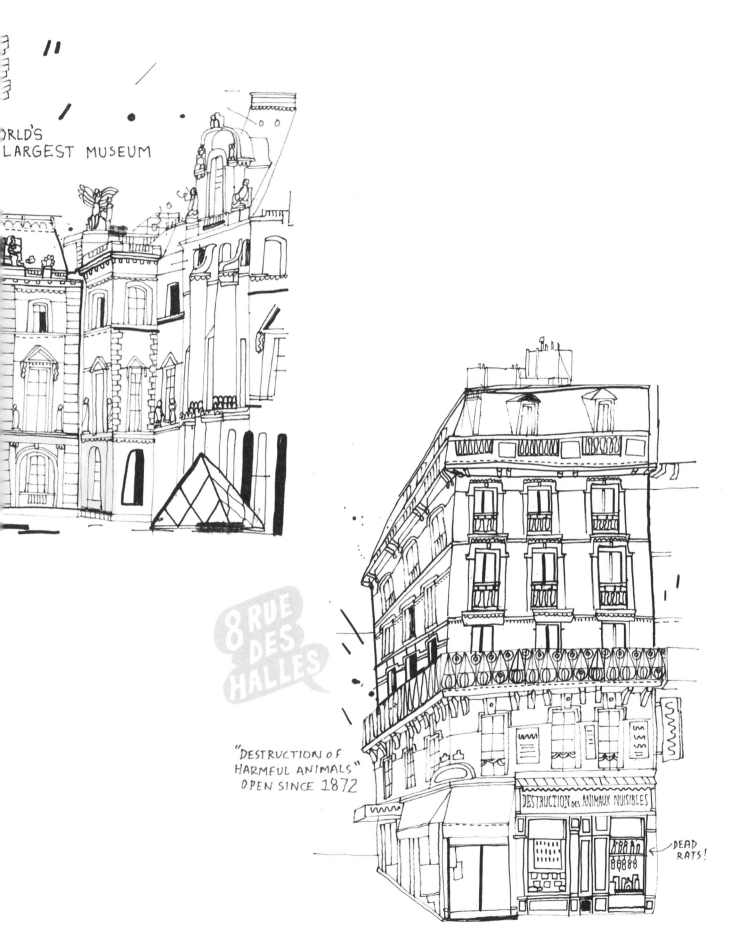

ORLD'S
LARGEST MUSEUM

8 RUE DES HALLES

"DESTRUCTION OF
HARMFUL ANIMALS"
OPEN SINCE 1872

DESTRUCTION des ANIMAUX NUISIBLES

DEAD RATS!

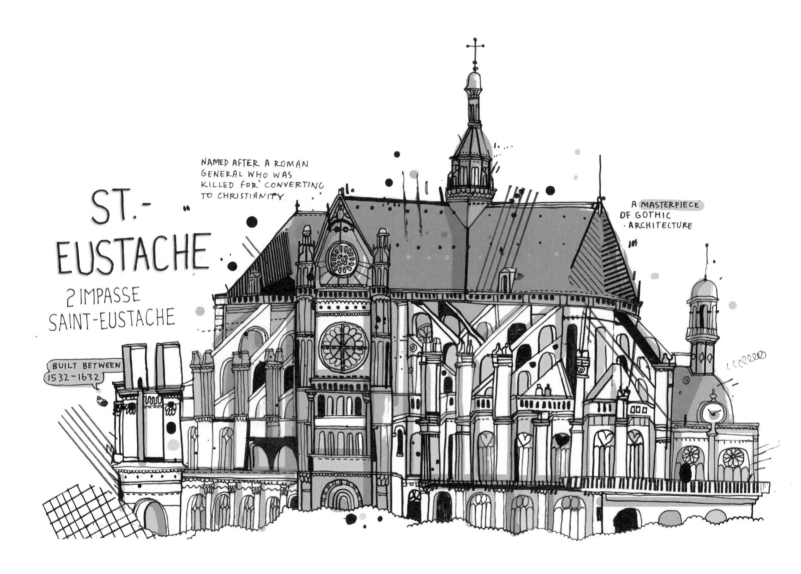

ST.-
EUSTACHE

2 IMPASSE
SAINT-EUSTACHE

NAMED AFTER A ROMAN
GENERAL WHO WAS
KILLED FOR CONVERTING
TO CHRISTIANITY

A MASTERPIECE
OF GOTHIC
ARCHITECTURE

BUILT BETWEEN
1532 - 1632

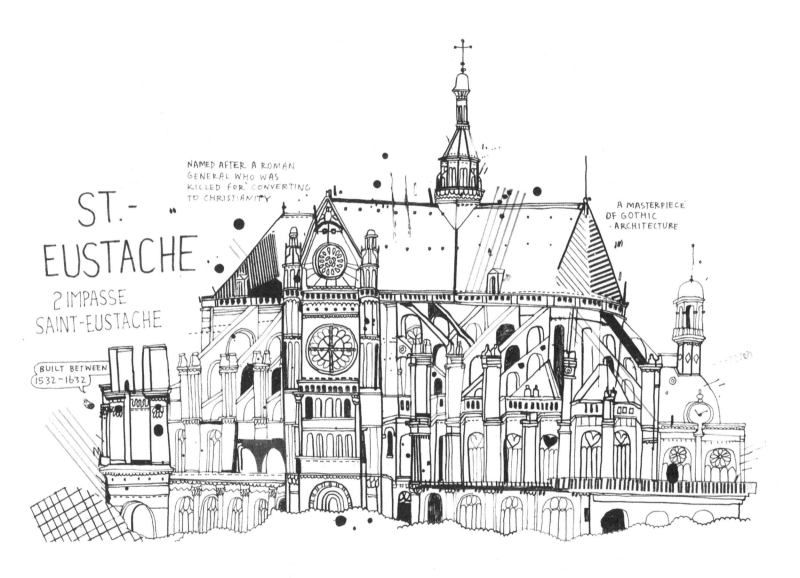

ST.- EUSTACHE

2 IMPASSE SAINT-EUSTACHE

NAMED AFTER A ROMAN GENERAL WHO WAS KILLED FOR CONVERTING TO CHRISTIANITY

A MASTERPIECE OF GOTHIC ARCHITECTURE

BUILT BETWEEN 1532-1632

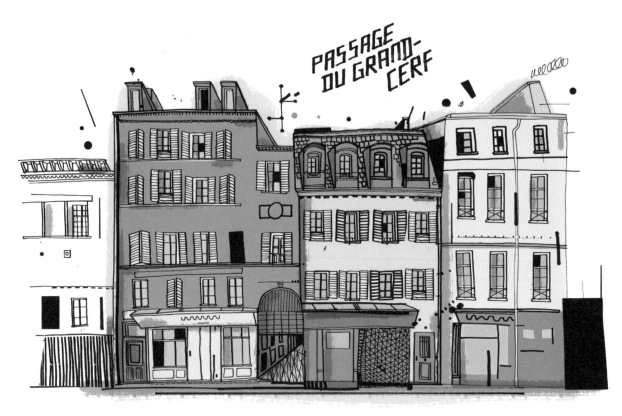

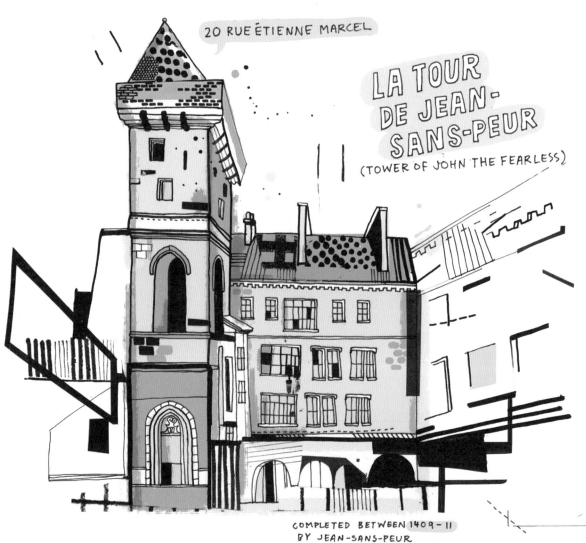

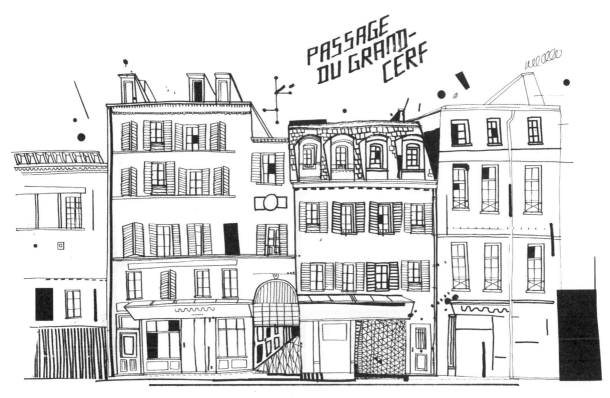

PASSAGE DU GRAND-CERF

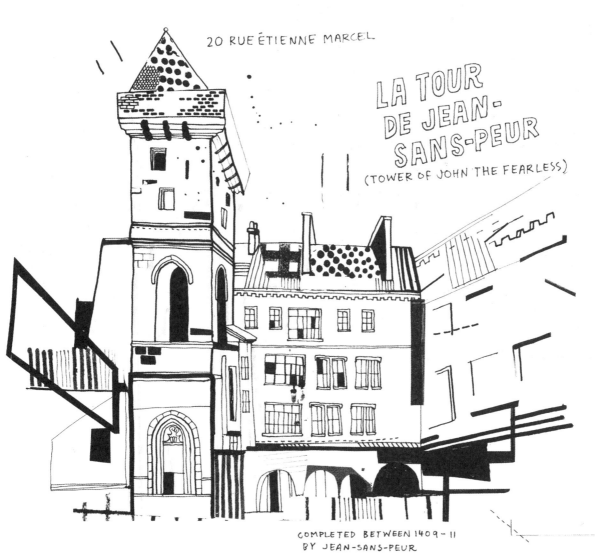

20 RUE ÉTIENNE MARCEL

LA TOUR DE JEAN-SANS-PEUR
(TOWER OF JOHN THE FEARLESS)

COMPLETED BETWEEN 1409-11 BY JEAN-SANS-PEUR

19

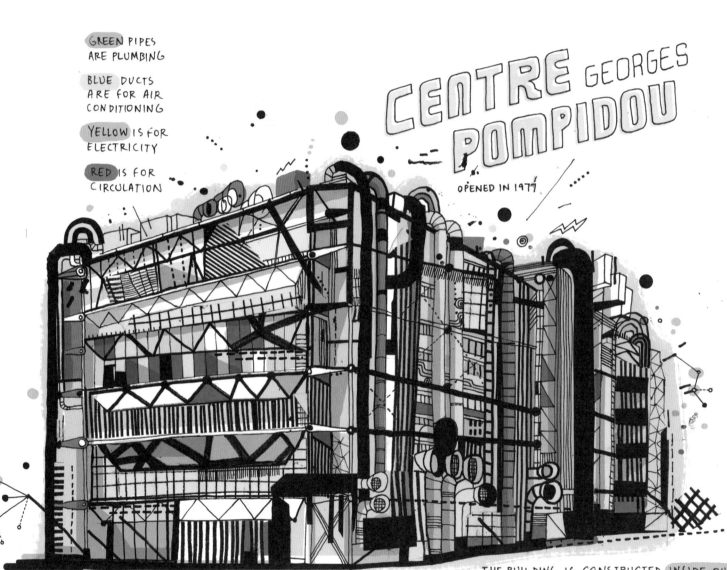

GREEN PIPES ARE PLUMBING

BLUE DUCTS ARE FOR AIR CONDITIONING

YELLOW IS FOR ELECTRICITY

RED IS FOR CIRCULATION

CENTRE GEORGES POMPIDOU

OPENED IN 1977

THE BUILDING IS CONSTRUCTED INSIDE OUT, WITH ALL THE UTILITIES ON THE OUTSIDE.

DESIGNED BY:
RICHARD ROGERS
RENZO PIANO
GIANFRANCO FRANCHINI

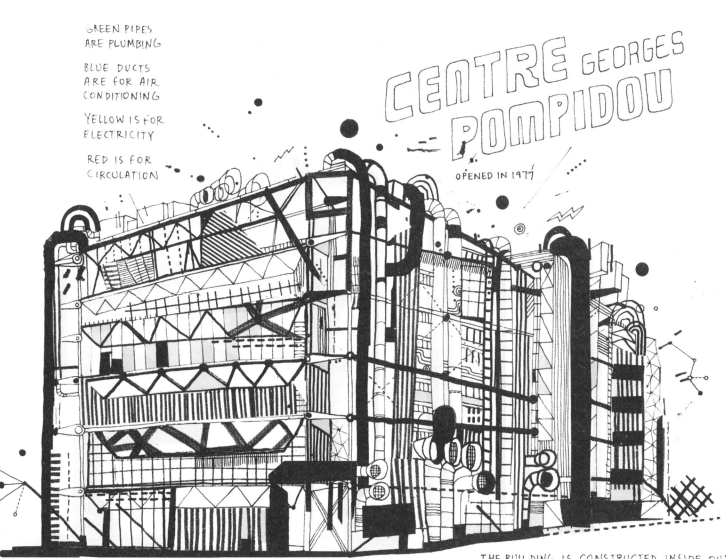

GREEN PIPES
ARE PLUMBING

BLUE DUCTS
ARE FOR AIR
CONDITIONING

YELLOW IS FOR
ELECTRICITY

RED IS FOR
CIRCULATION

CENTRE GEORGES POMPIDOU

OPENED IN 1977

THE BUILDING IS CONSTRUCTED INSIDE OUT,
WITH ALL THE UTILITIES ON THE OUTSIDE.

DESIGNED BY:
RICHARD ROGERS
RENZO PIANO
GIANFRANCO FRANCHINI

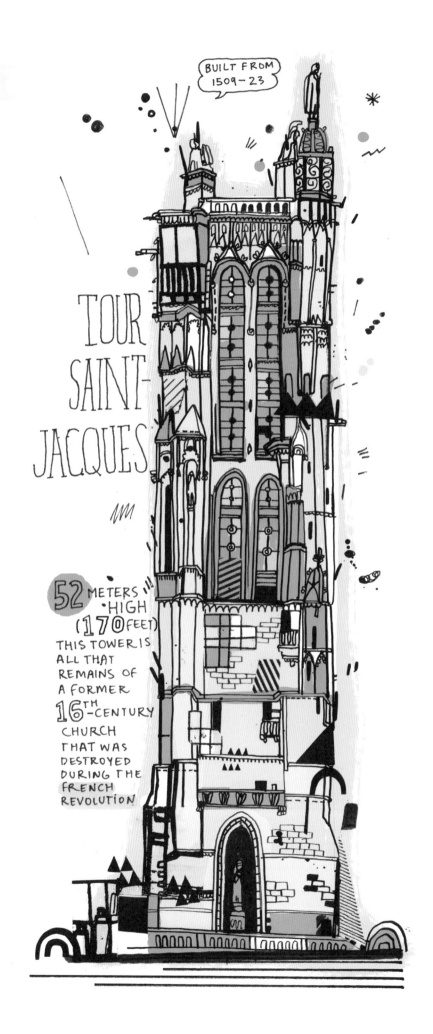

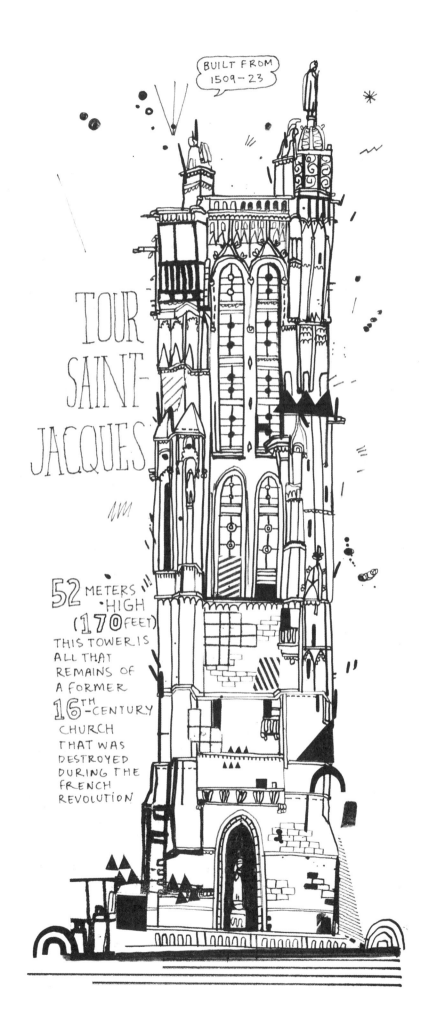

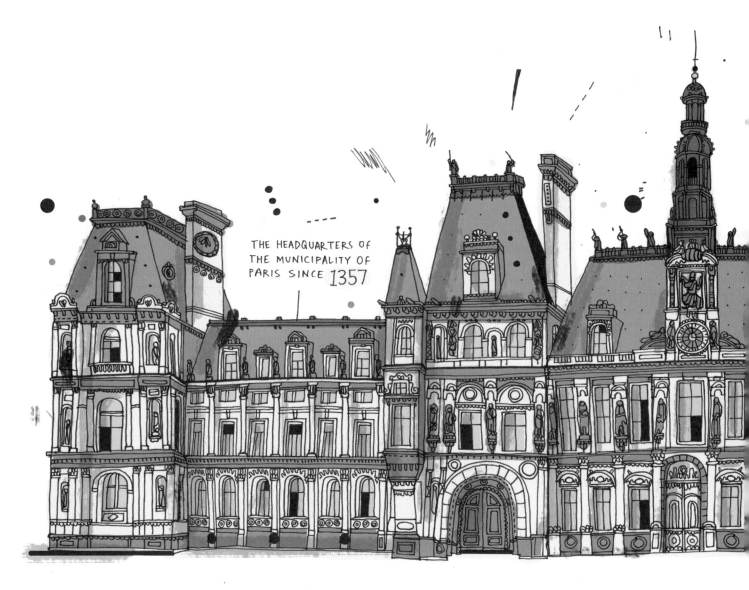

THE HEADQUARTERS OF THE MUNICIPALITY OF PARIS SINCE 1357

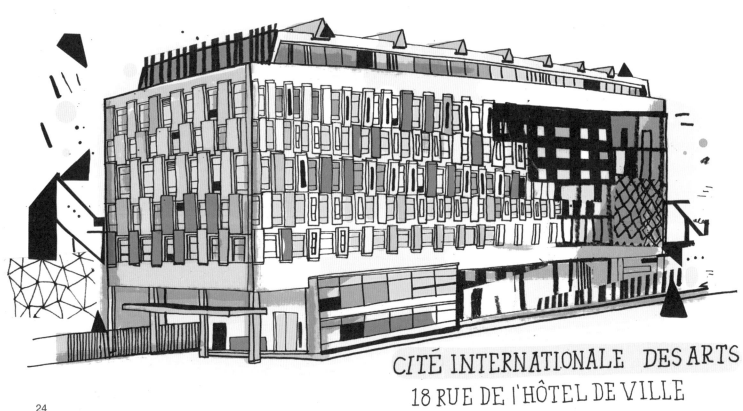

CITÉ INTERNATIONALE DES ARTS
18 RUE DE l'HÔTEL DE VILLE

COMMUNARDS SET FIRE TO THE
..., LEAVING ONLY A STONE
...WHICH WAS
IN 1873-92.

# HÔTEL DE VILLE

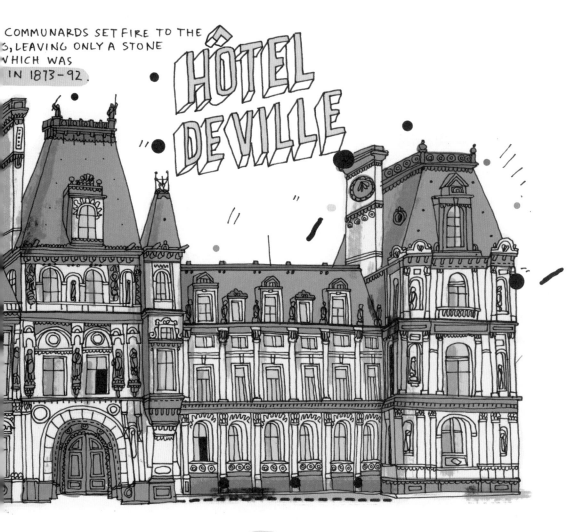

66 Quai de l'Hotel de ville

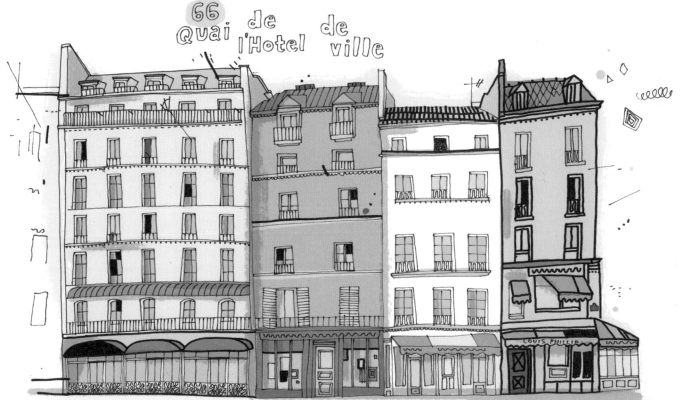

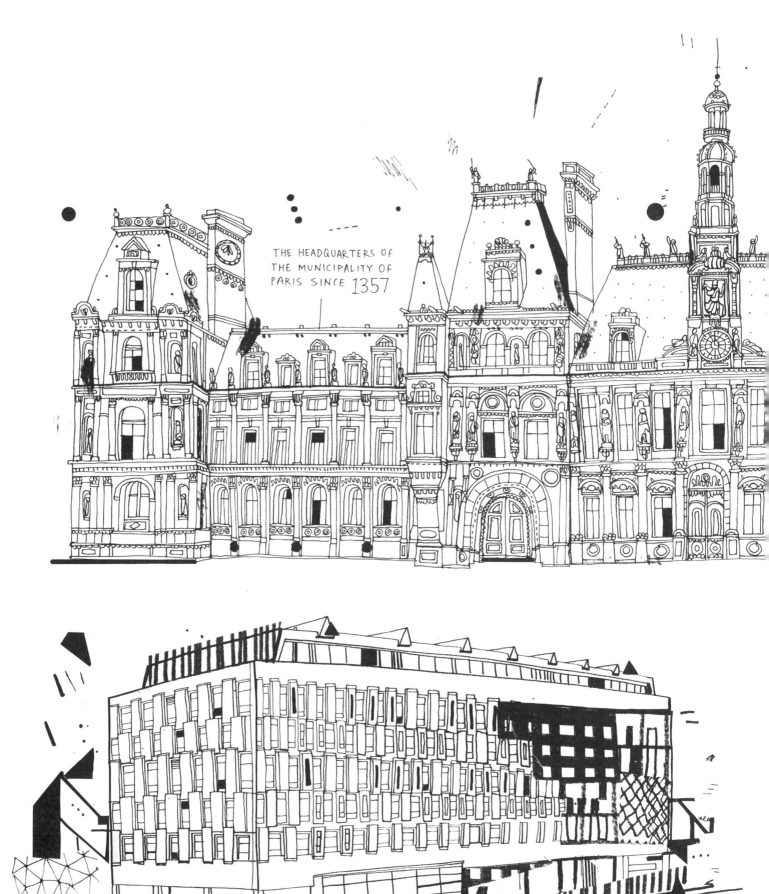

THE HEADQUARTERS OF
THE MUNICIPALITY OF
PARIS SINCE 1357

CITÉ INTERNATIONALE DES ARTS
18 RUE DE l'HÔTEL DE VILLE

COMMUNARDS SET FIRE TO THE
[...]6, LEAVING ONLY A STONE
[...]WHICH WAS
[...] IN 1873-92.

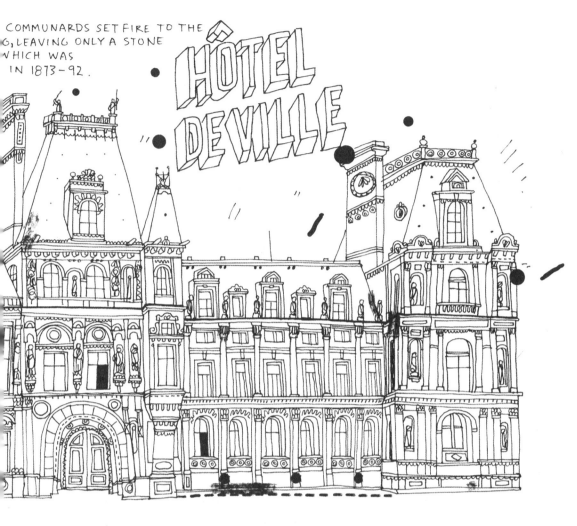

HÔTEL DE VILLE

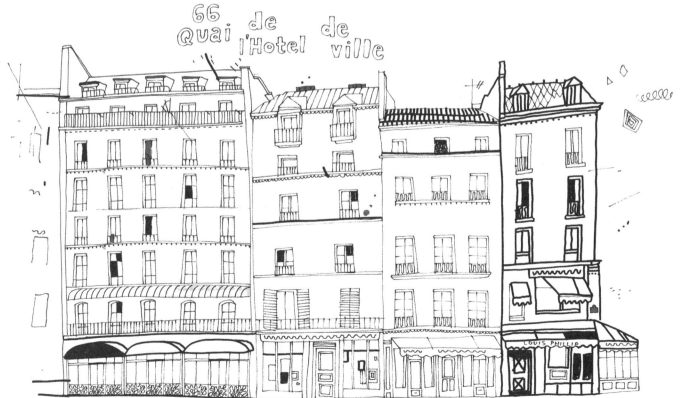

66 Quai de l'Hotel de ville

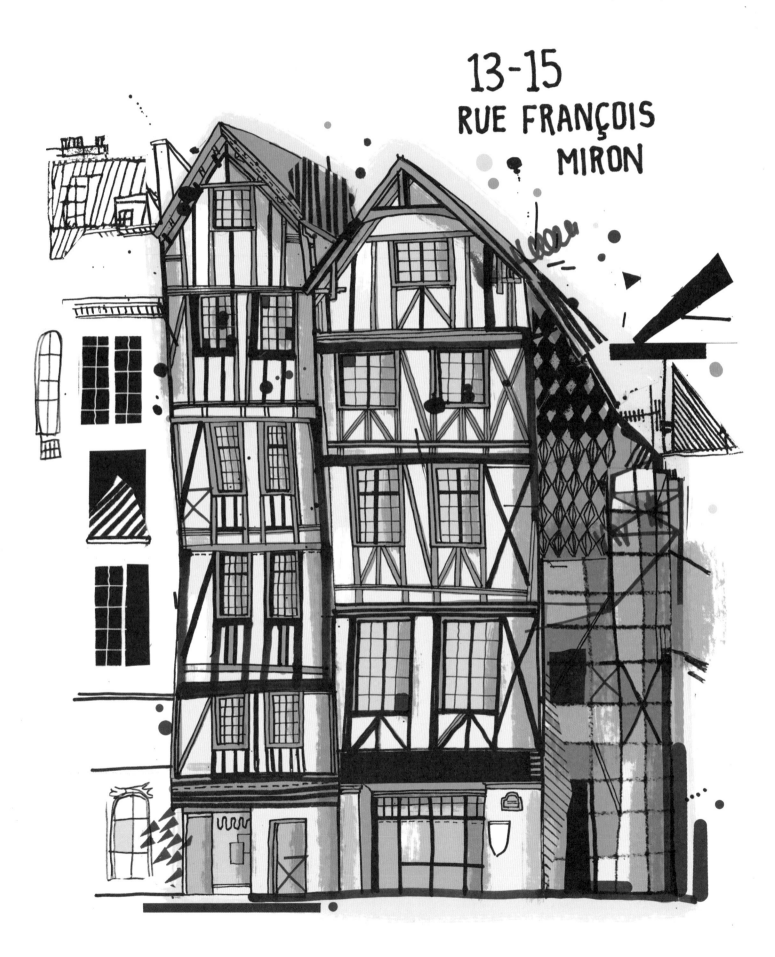

13-15
RUE FRANÇOIS
MIRON

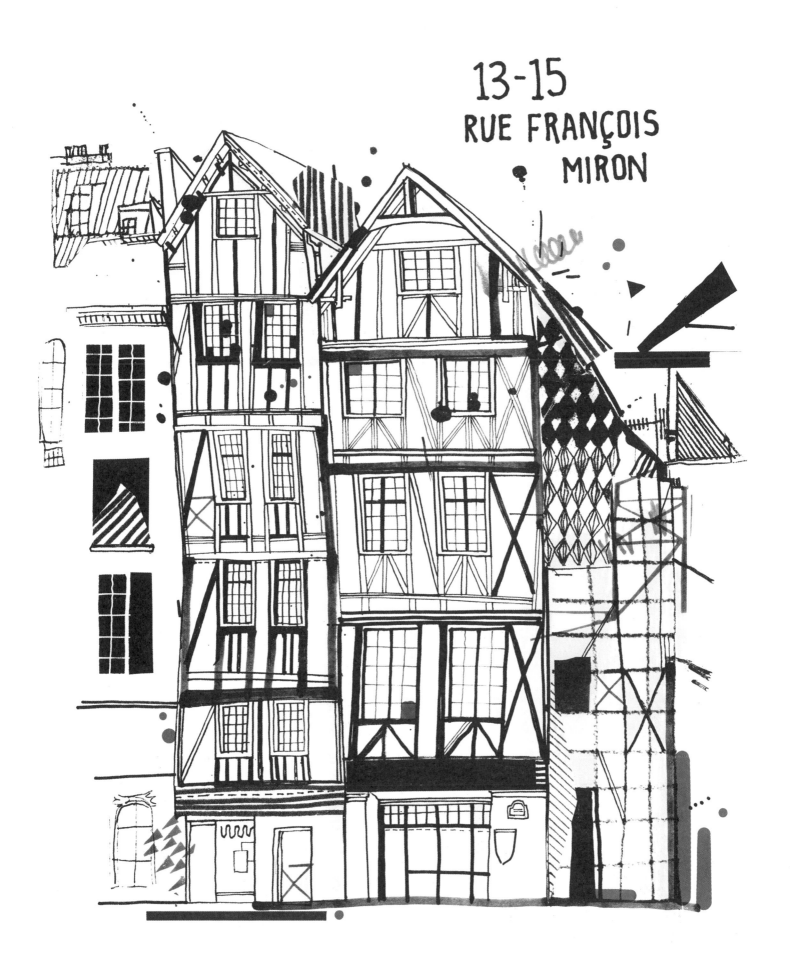

13-15
RUE FRANÇOIS
MIRON

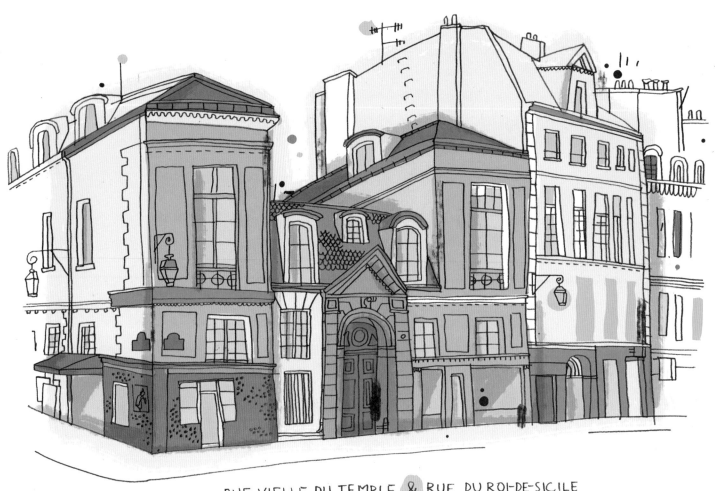

RUE VIELLE DU TEMPLE & RUE DU ROI-DE-SICILE

PLACE DES VOSGES

BUILT DURING HENRY IV'S REIGN FROM 1605-12 AS A MODEL FOR ROYAL CITY PLANNING

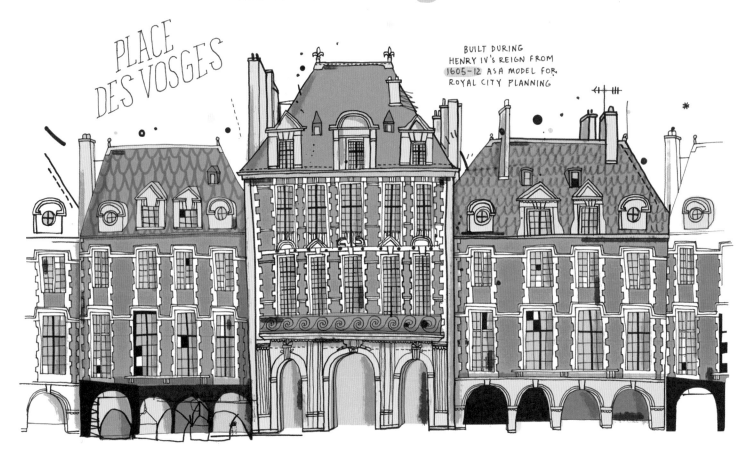

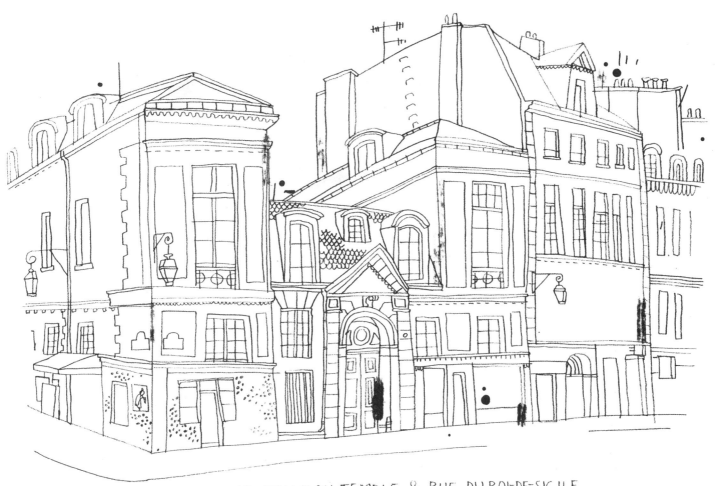

RUE VIELLE DU TEMPLE & RUE DU ROI-DE-SICILE

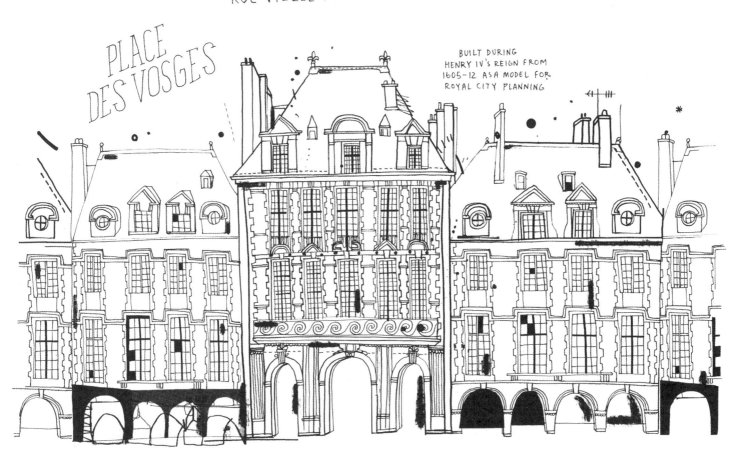

PLACE DES VOSGES

BUILT DURING
HENRY IV'S REIGN FROM
1605-12 ASA MODEL FOR
ROYAL CITY PLANNING

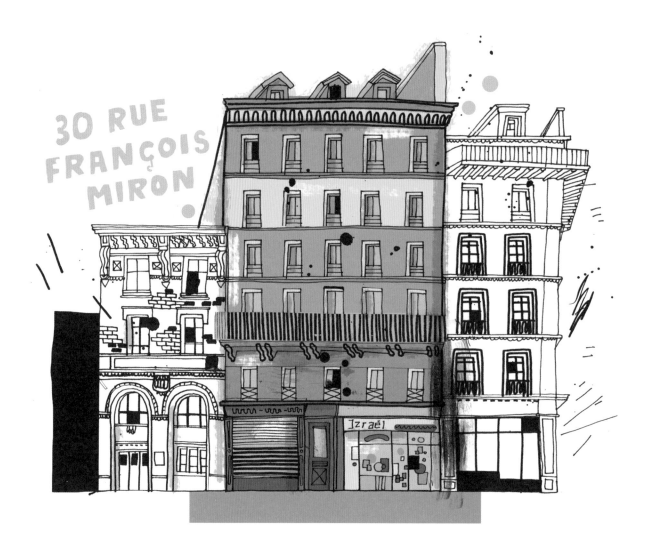

30 RUE
FRANÇOIS
MIRON

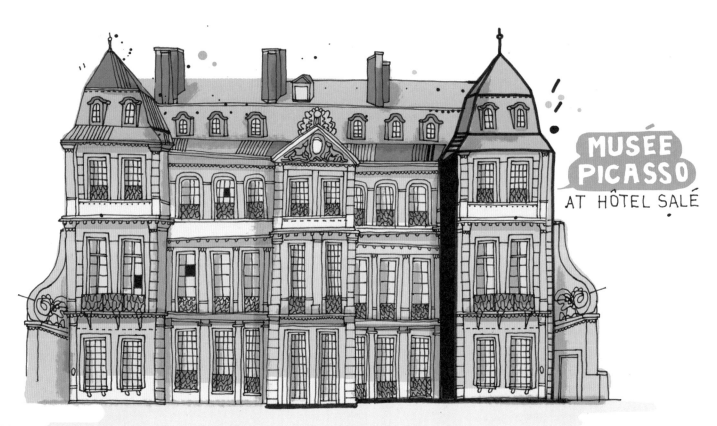

MUSÉE
PICASSO
AT HÔTEL SALÉ

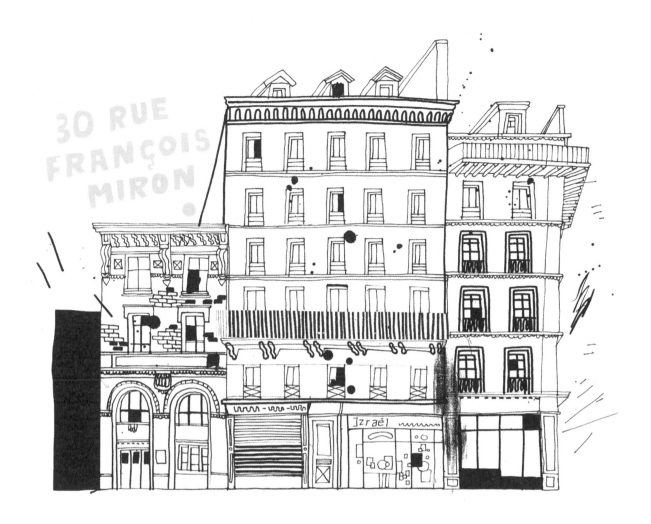

30 RUE
FRANÇOIS
MIRON

Izraël

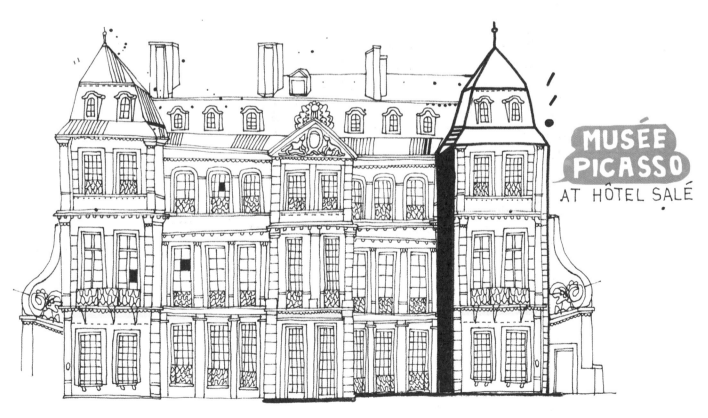

MUSÉE
PICASSO
AT HÔTEL SALÉ

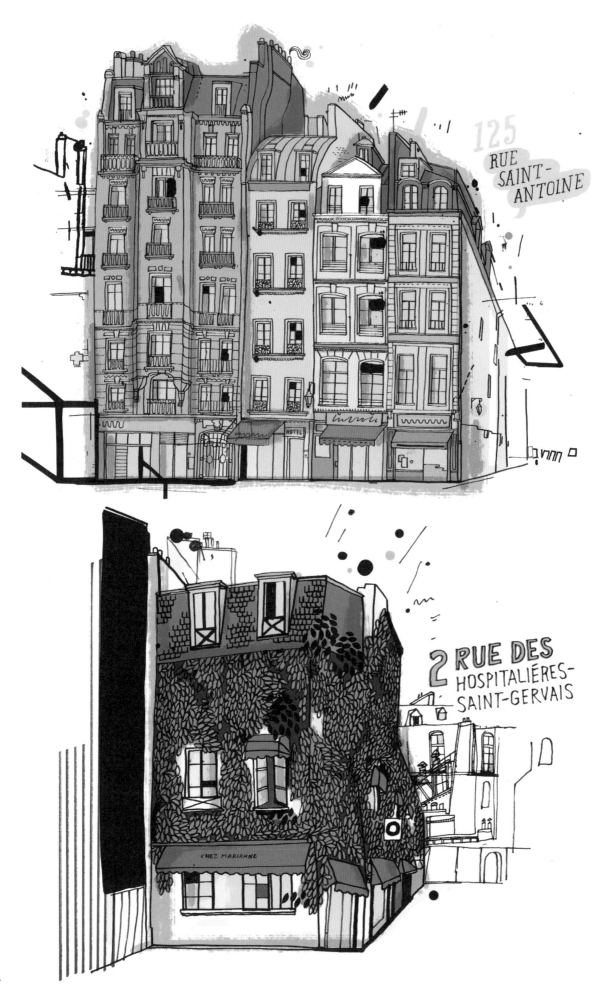

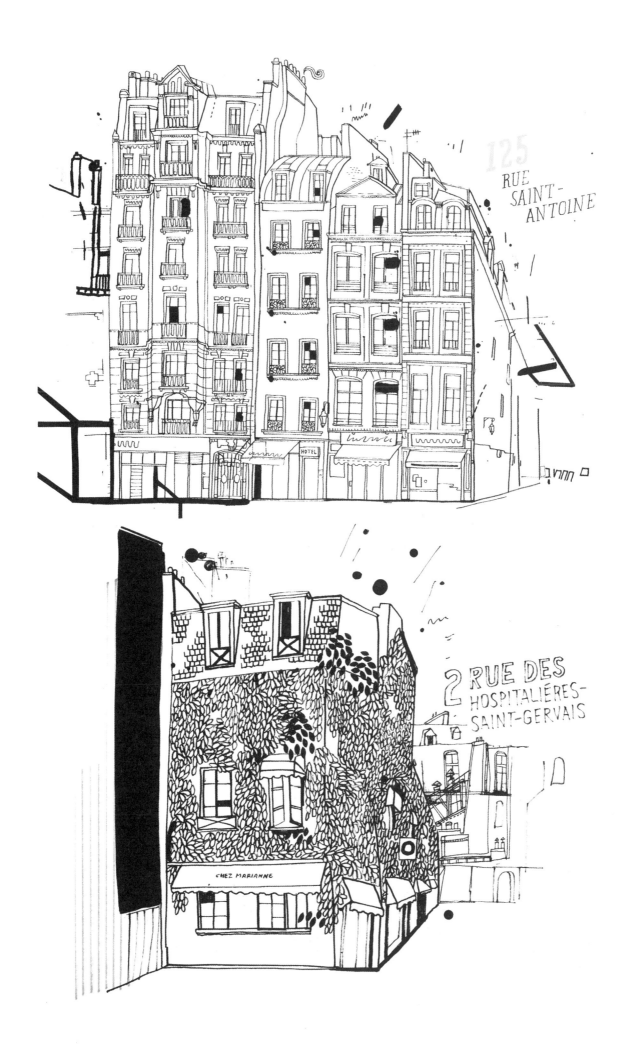

125
RUE
SAINT-
ANTOINE

2 RUE DES
HOSPITALIÈRES-
SAINT-GERVAIS

CHEZ MARIANNE

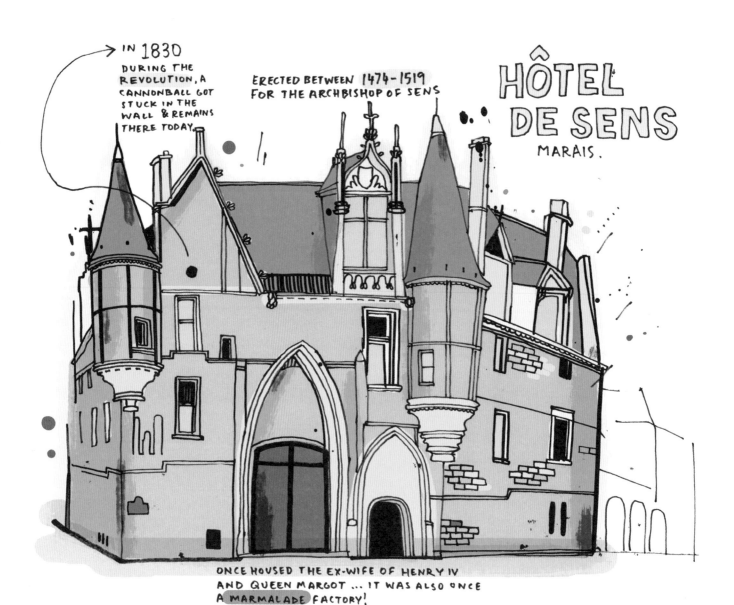

IN 1830 DURING THE REVOLUTION, A CANNONBALL GOT STUCK IN THE WALL & REMAINS THERE TODAY.

ERECTED BETWEEN 1474-1519 FOR THE ARCHBISHOP OF SENS

# HÔTEL DE SENS
MARAIS.

ONCE HOUSED THE EX-WIFE OF HENRY IV AND QUEEN MARGOT ... IT WAS ALSO ONCE A MARMALADE FACTORY!

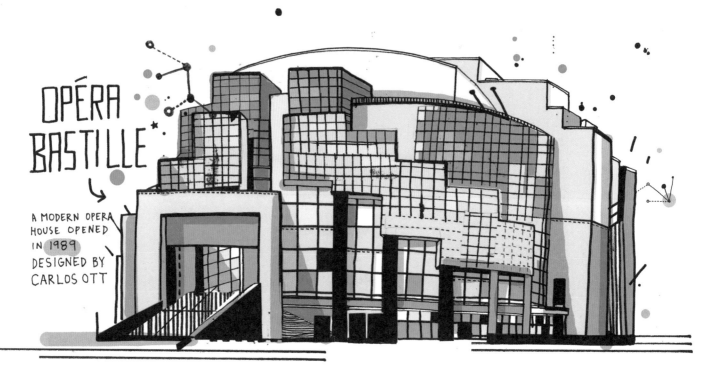

# OPÉRA BASTILLE

A MODERN OPERA HOUSE OPENED IN 1989 DESIGNED BY CARLOS OTT

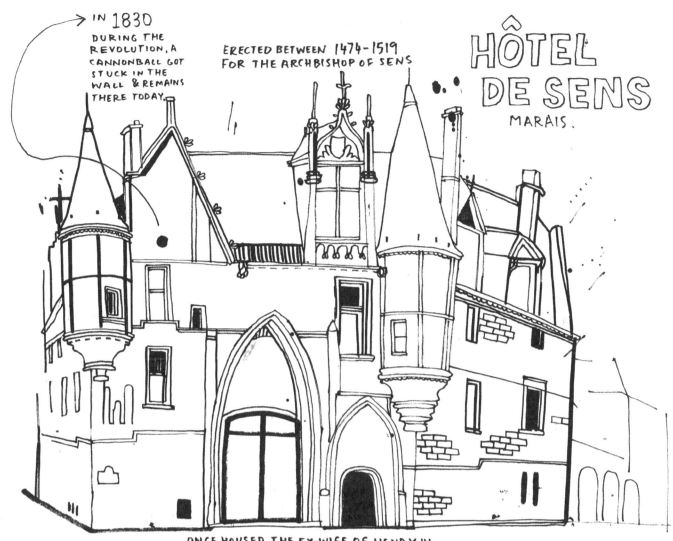

IN 1830 DURING THE REVOLUTION, A CANNONBALL GOT STUCK IN THE WALL & REMAINS THERE TODAY.

ERECTED BETWEEN 1474-1519 FOR THE ARCHBISHOP OF SENS

# HÔTEL DE SENS
## MARAIS.

ONCE HOUSED THE EX-WIFE OF HENRY IV AND QUEEN MARGOT ... IT WAS ALSO ONCE A MARMALADE FACTORY!

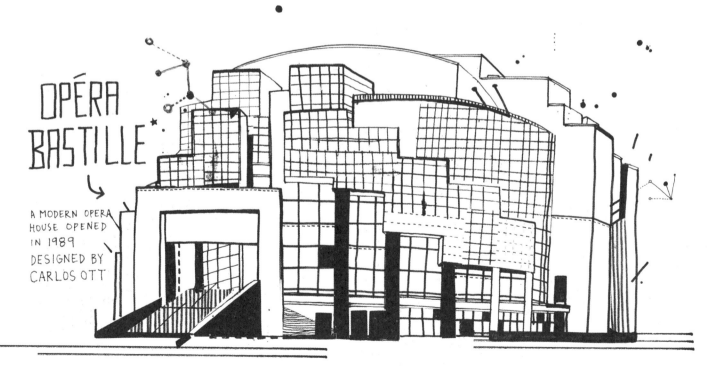

# OPÉRA BASTILLE

A MODERN OPERA HOUSE OPENED IN 1989 DESIGNED BY CARLOS OTT

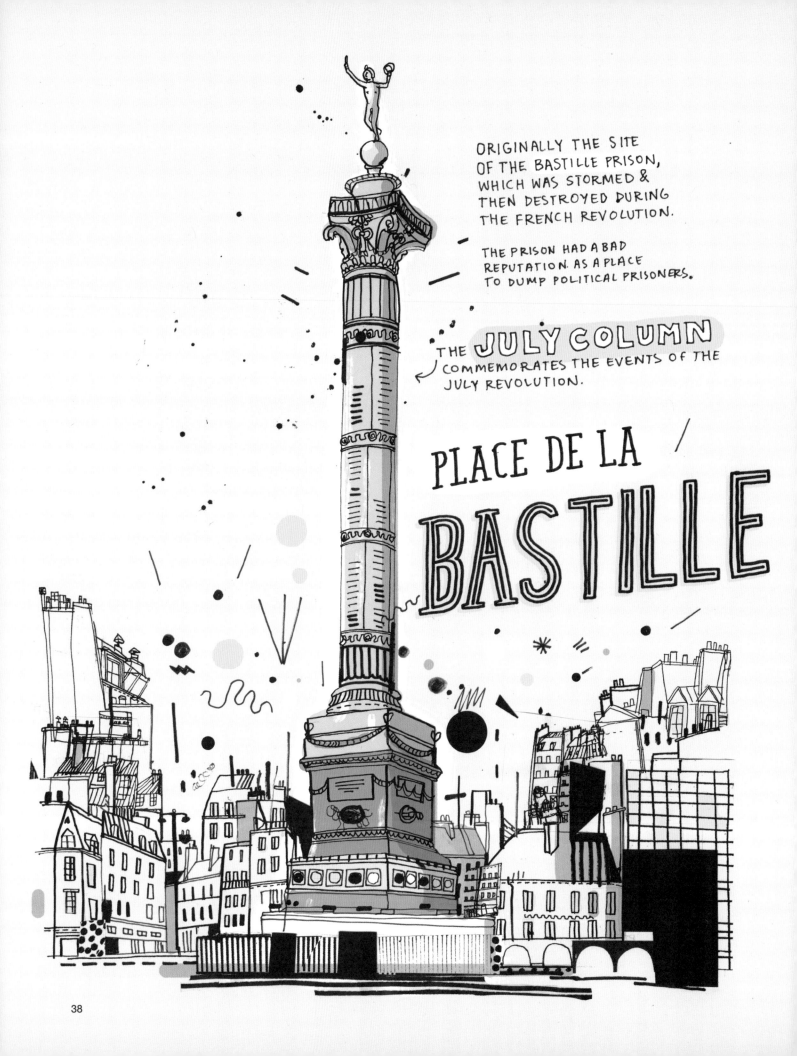

ORIGINALLY THE SITE OF THE BASTILLE PRISON, WHICH WAS STORMED & THEN DESTROYED DURING THE FRENCH REVOLUTION.

THE PRISON HAD A BAD REPUTATION. AS A PLACE TO DUMP POLITICAL PRISONERS.

THE **JULY COLUMN** COMMEMORATES THE EVENTS OF THE JULY REVOLUTION.

# PLACE DE LA BASTILLE

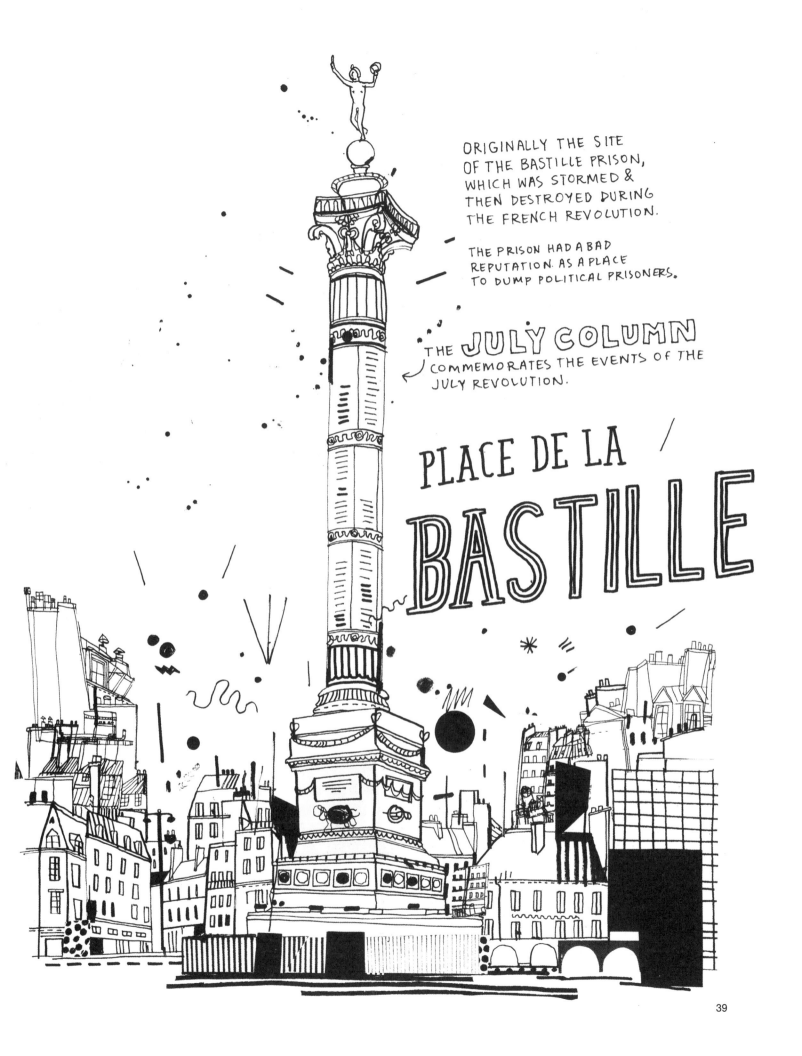

ORIGINALLY THE SITE OF THE BASTILLE PRISON, WHICH WAS STORMED & THEN DESTROYED DURING THE FRENCH REVOLUTION.

THE PRISON HAD A BAD REPUTATION AS A PLACE TO DUMP POLITICAL PRISONERS.

THE JULY COLUMN COMMEMORATES THE EVENTS OF THE JULY REVOLUTION.

PLACE DE LA BASTILLE

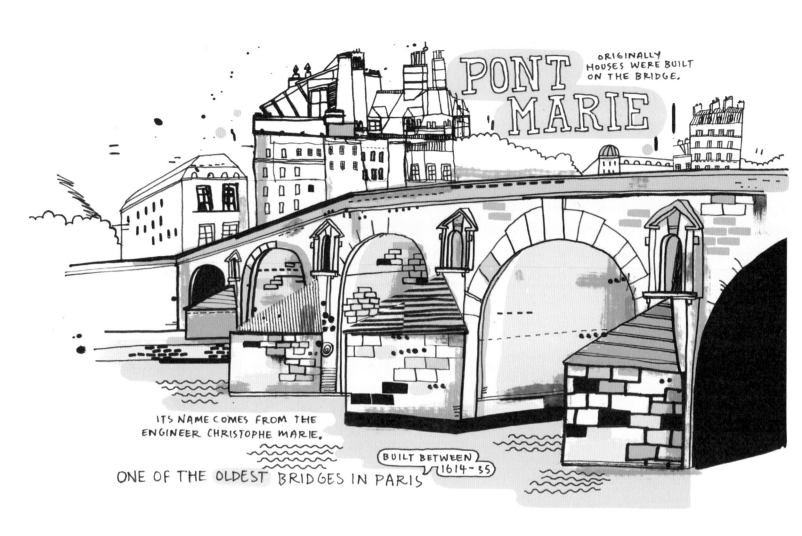

ORIGINALLY HOUSES WERE BUILT ON THE BRIDGE.

**PONT MARIE**

ITS NAME COMES FROM THE ENGINEER CHRISTOPHE MARIE.

BUILT BETWEEN 1614-35

ONE OF THE OLDEST BRIDGES IN PARIS

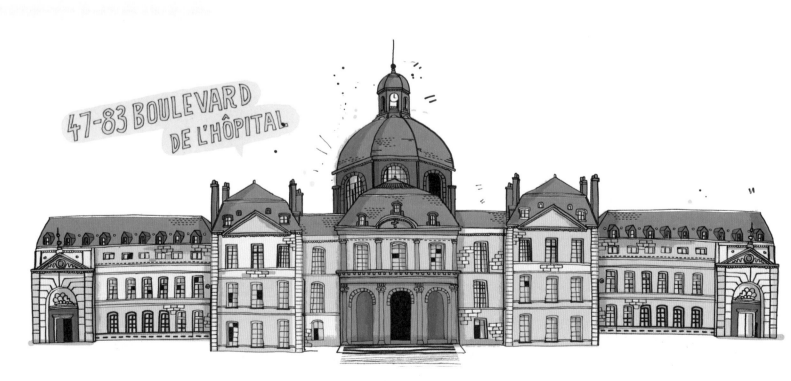

**47-83 BOULEVARD DE L'HÔPITAL**

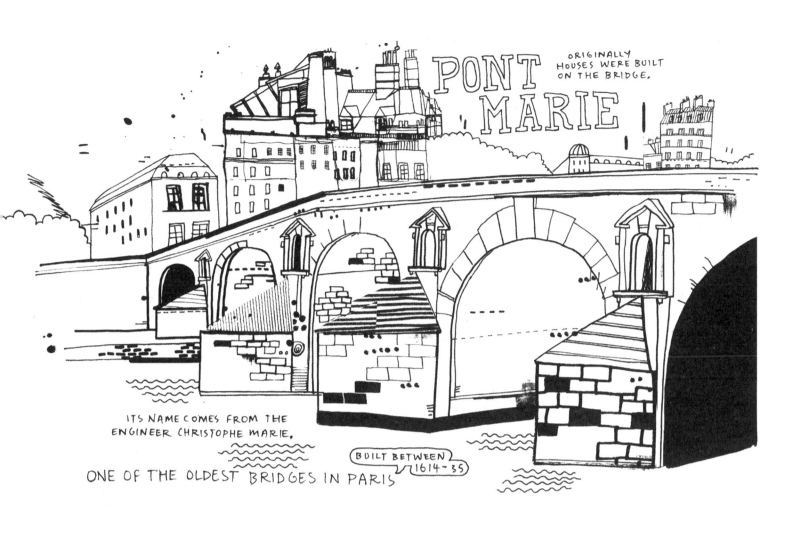

**PONT MARIE**

ORIGINALLY HOUSES WERE BUILT ON THE BRIDGE.

ITS NAME COMES FROM THE ENGINEER CHRISTOPHE MARIE.

BUILT BETWEEN 1614-35

ONE OF THE OLDEST BRIDGES IN PARIS

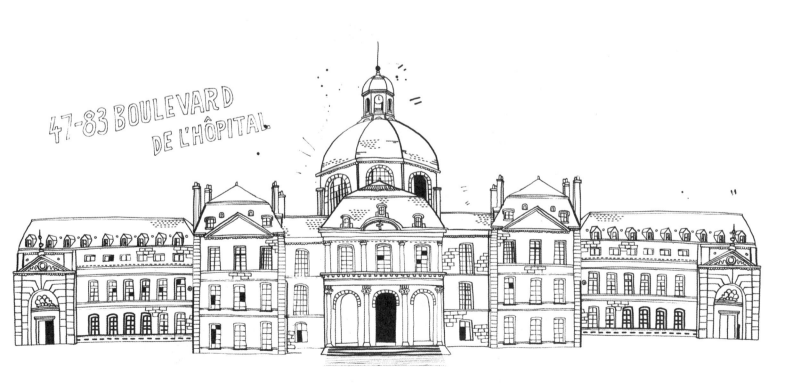

**47-83 BOULEVARD DE L'HÔPITAL**

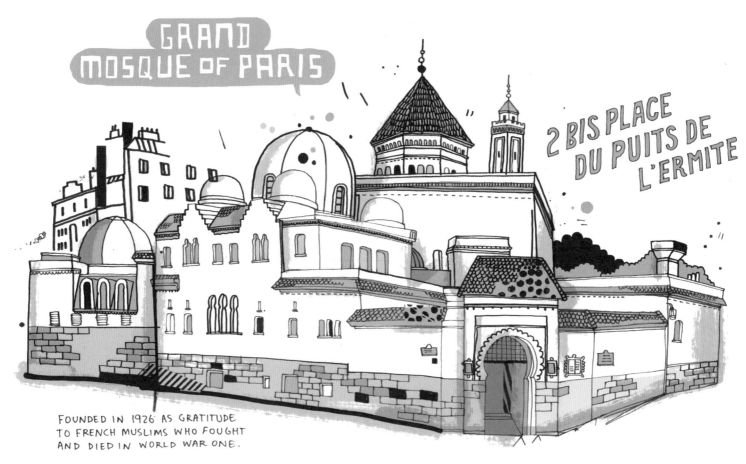

# GRAND MOSQUE OF PARIS

## 2 BIS PLACE DU PUITS DE L'ERMITE

FOUNDED IN 1926 AS GRATITUDE TO FRENCH MUSLIMS WHO FOUGHT AND DIED IN WORLD WAR ONE.

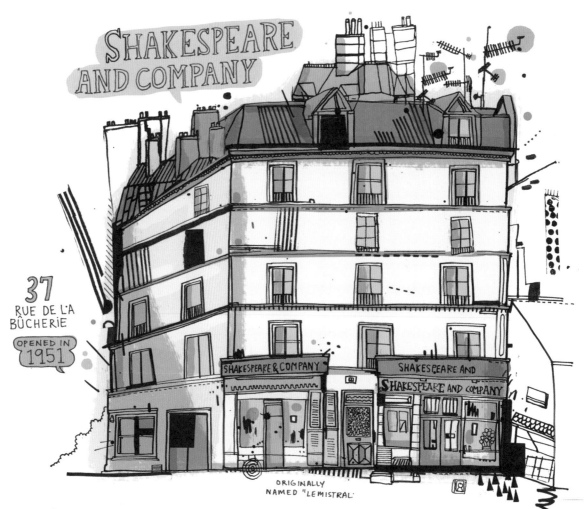

# SHAKESPEARE AND COMPANY

37 RUE DE L'A BÛCHERIE

OPENED IN 1951

SHAKESPEARE & COMPANY

SHAKESPEARE AND

SHAKESPEARE AND COMPANY

ORIGINALLY NAMED "LE MISTRAL"

# GRAND MOSQUE OF PARIS

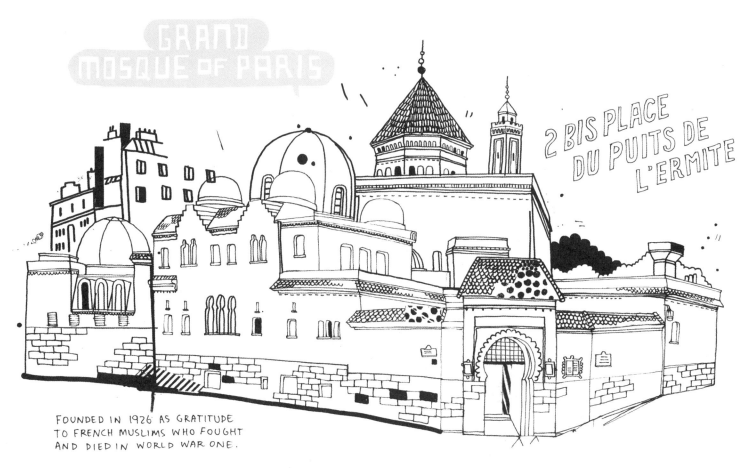

2 BIS PLACE DU PUITS DE L'ERMITE

FOUNDED IN 1926 AS GRATITUDE TO FRENCH MUSLIMS WHO FOUGHT AND DIED IN WORLD WAR ONE.

# SHAKESPEARE AND COMPANY

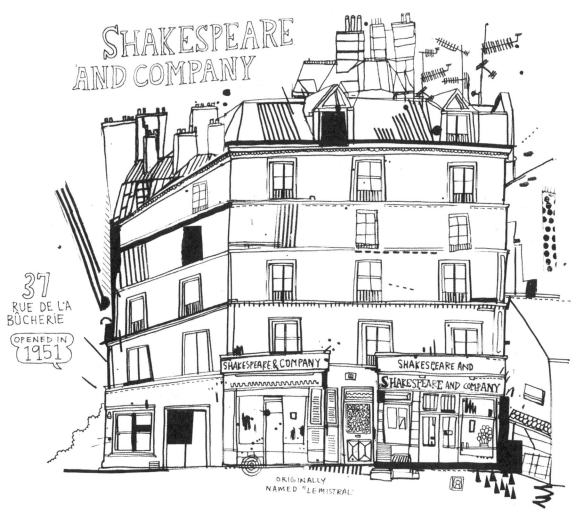

37 RUE DE L'A BÛCHERIE

OPENED IN 1951

SHAKESPEARE & COMPANY

SHAKESPEARE AND SHAKESPEARE AND COMPANY

ORIGINALLY NAMED "LE MISTRAL"

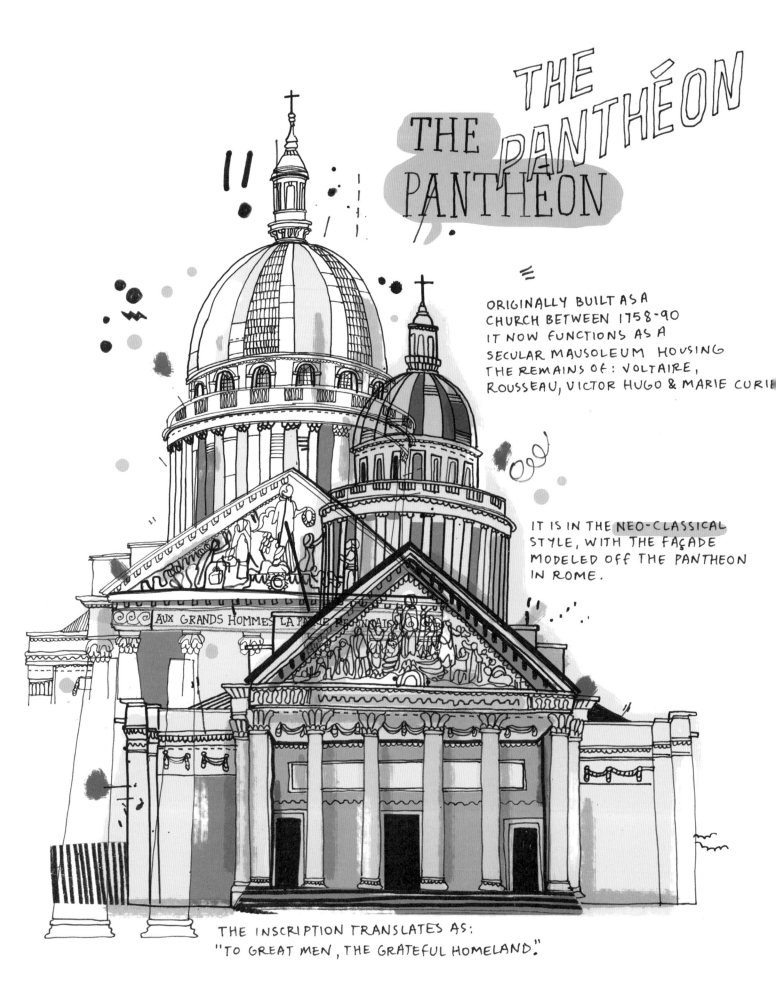

THE PANTHÉON

THE PANTHEON

ORIGINALLY BUILT AS A CHURCH BETWEEN 1758-90 IT NOW FUNCTIONS AS A SECULAR MAUSOLEUM HOUSING THE REMAINS OF: VOLTAIRE, ROUSSEAU, VICTOR HUGO & MARIE CURIE

IT IS IN THE NEO-CLASSICAL STYLE, WITH THE FAÇADE MODELED OFF THE PANTHEON IN ROME.

AUX GRANDS HOMMES LA PATRIE RECONNAISSANTE

THE INSCRIPTION TRANSLATES AS: "TO GREAT MEN, THE GRATEFUL HOMELAND."

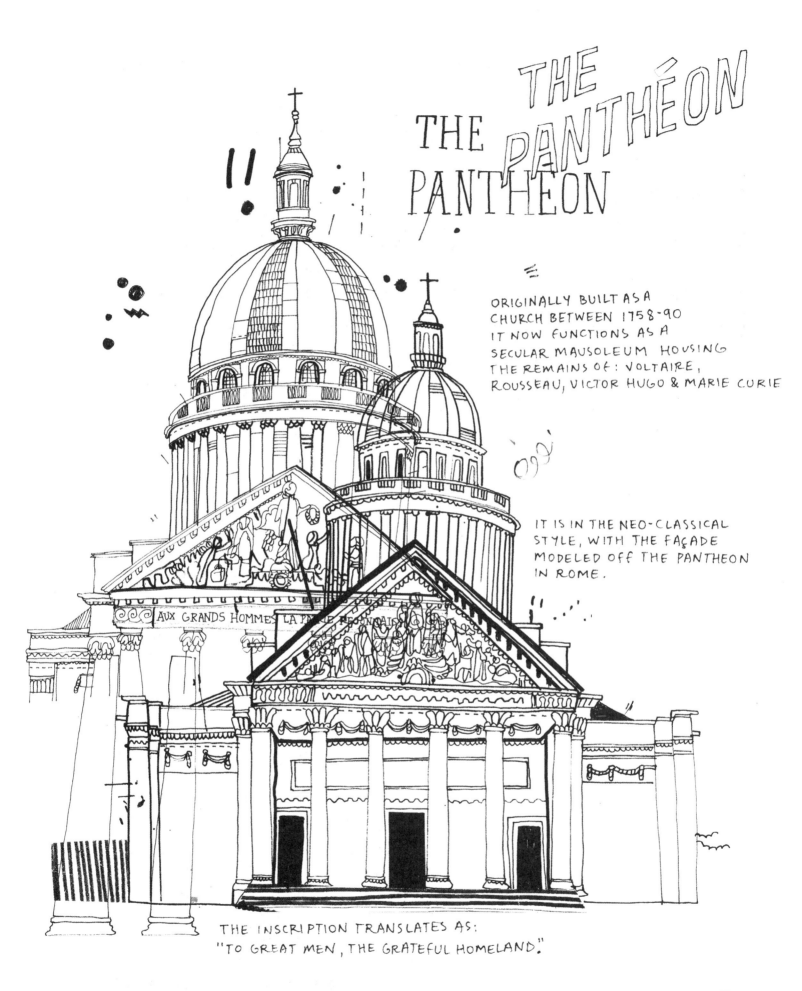

# THE THE PANTHÉON
# THE PANTHEON

ORIGINALLY BUILT AS A
CHURCH BETWEEN 1758-90
IT NOW FUNCTIONS AS A
SECULAR MAUSOLEUM HOUSING
THE REMAINS OF: VOLTAIRE,
ROUSSEAU, VICTOR HUGO & MARIE CURIE

IT IS IN THE NEO-CLASSICAL
STYLE, WITH THE FAÇADE
MODELED OFF THE PANTHEON
IN ROME.

AUX GRANDS HOMMES LA PATRIE RECONNAISSANTE

THE INSCRIPTION TRANSLATES AS:
"TO GREAT MEN, THE GRATEFUL HOMELAND."

45

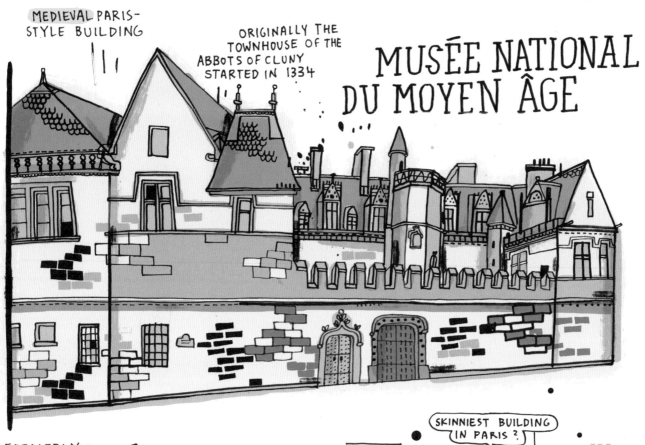

MEDIEVAL PARIS-STYLE BUILDING

ORIGINALLY THE TOWNHOUSE OF THE ABBOTS OF CLUNY STARTED IN 1334

# MUSÉE NATIONAL DU MOYEN ÂGE

FORMERLY

# MUSÉE DE CLUNY

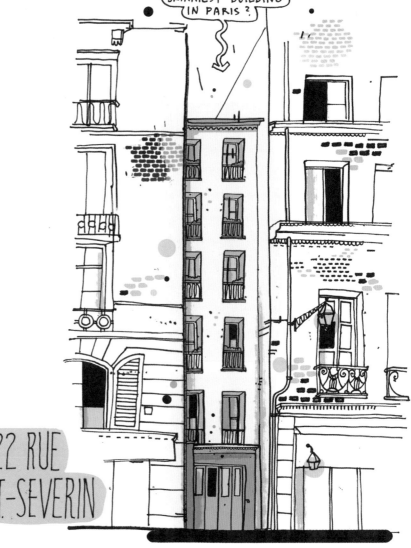

SKINNIEST BUILDING IN PARIS?

## 22 RUE ST-SEVERIN

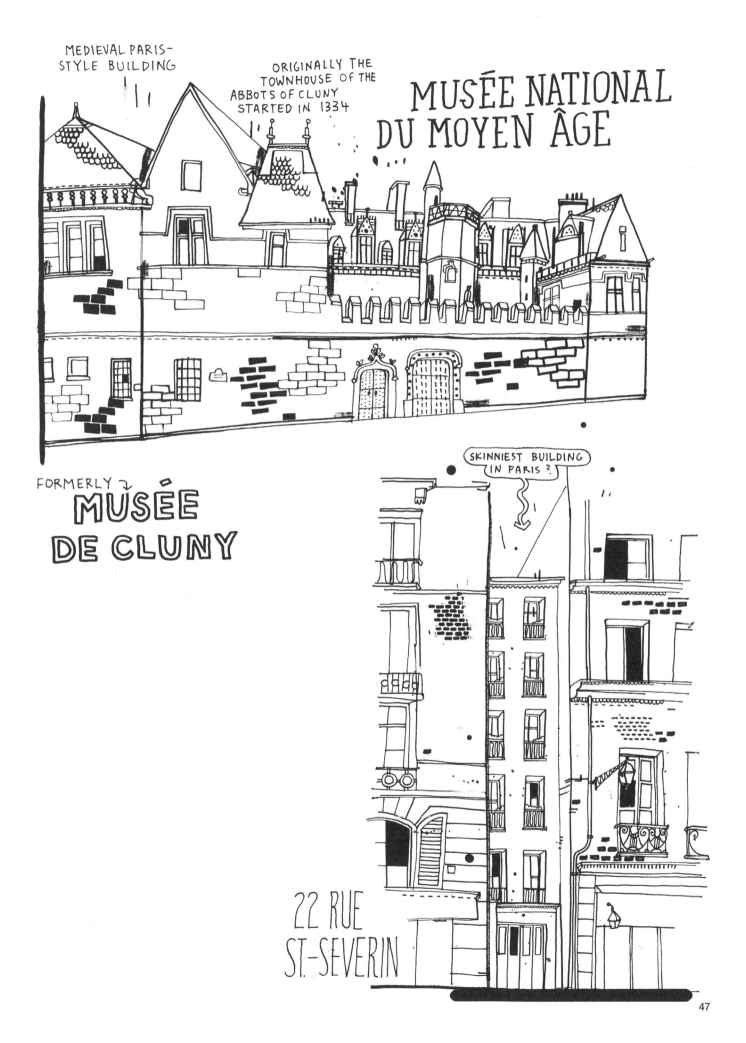

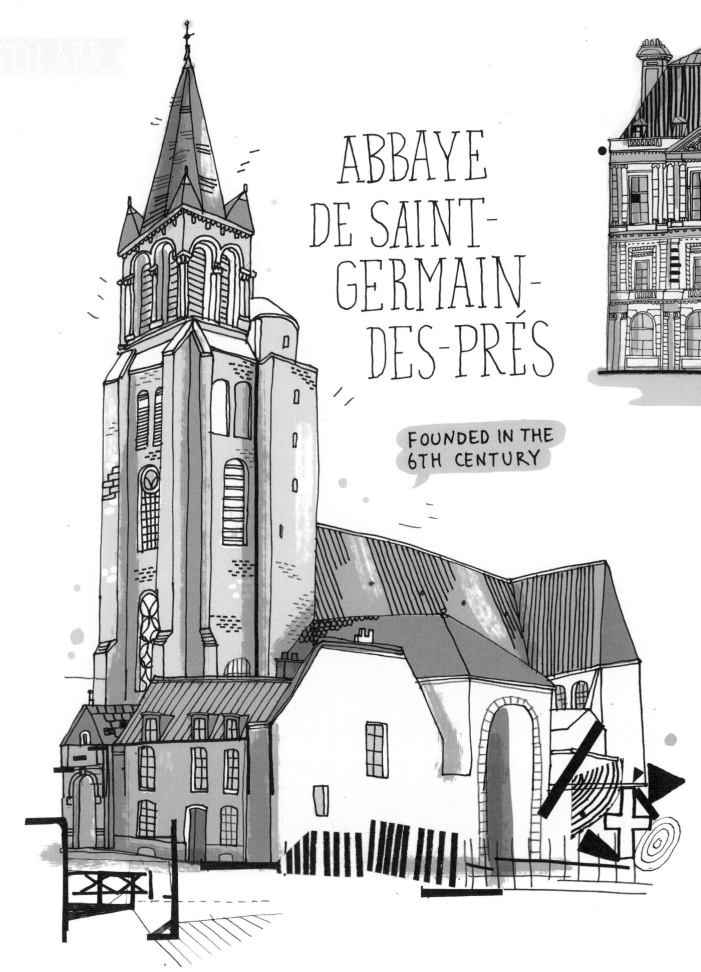

# ABBAYE DE SAINT-GERMAIN-DES-PRÉS

FOUNDED IN THE 6TH CENTURY

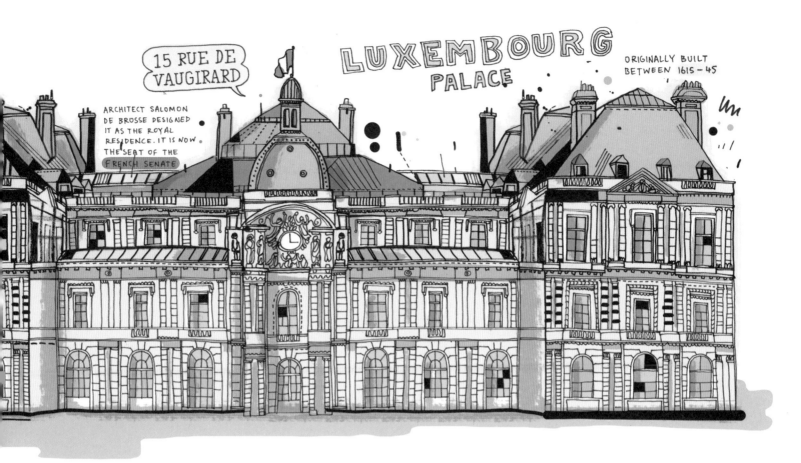

15 RUE DE VAUGIRARD

LUXEMBOURG PALACE

ORIGINALLY BUILT BETWEEN 1615-45

ARCHITECT SALOMON DE BROSSE DESIGNED IT AS THE ROYAL RESIDENCE. IT IS NOW THE SEAT OF THE FRENCH SENATE

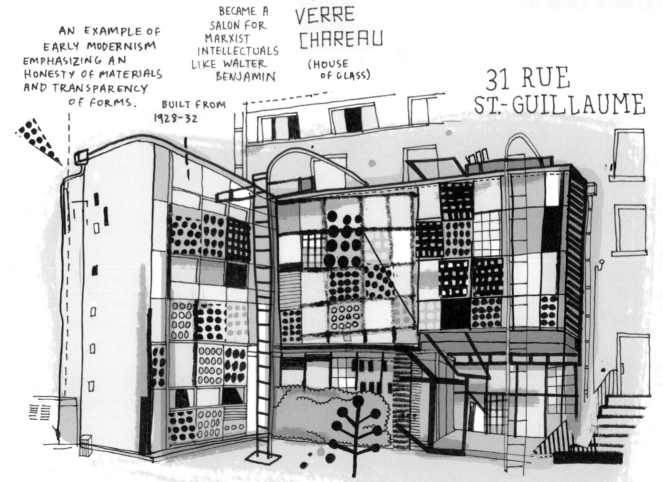

AN EXAMPLE OF EARLY MODERNISM EMPHASIZING AN HONESTY OF MATERIALS AND TRANSPARENCY OF FORMS.

BECAME A SALON FOR MARXIST INTELLECTUALS LIKE WALTER BENJAMIN

MAISON DE VERRE CHAREAU

(HOUSE OF GLASS)

BUILT FROM 1928-32

31 RUE ST-GUILLAUME

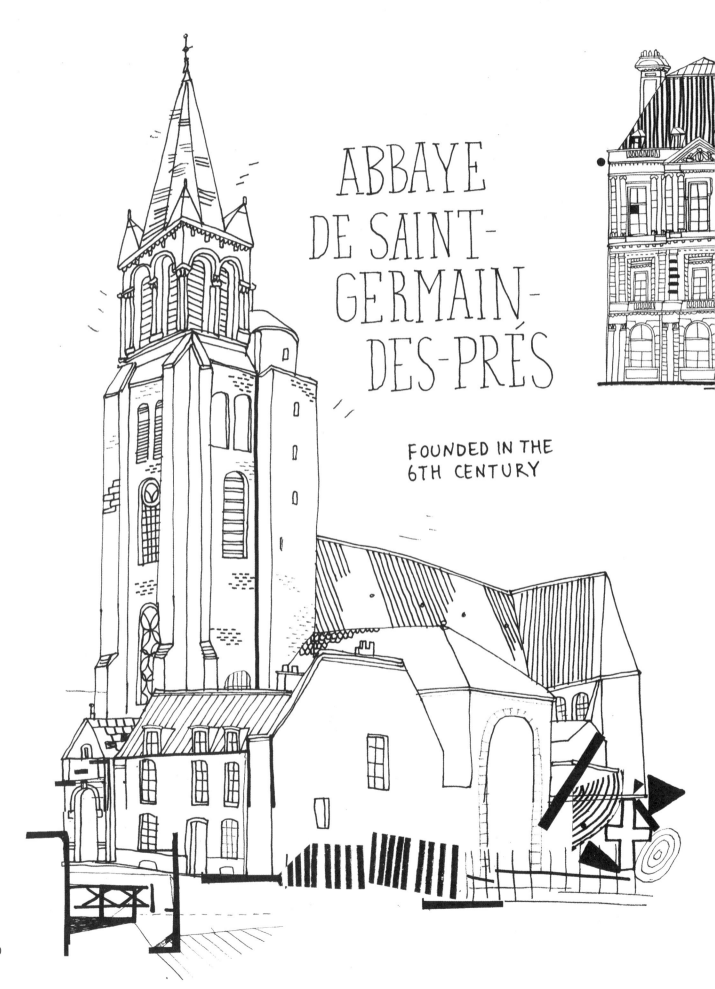

# ABBAYE DE SAINT-GERMAIN-DES-PRÉS

FOUNDED IN THE
6TH CENTURY

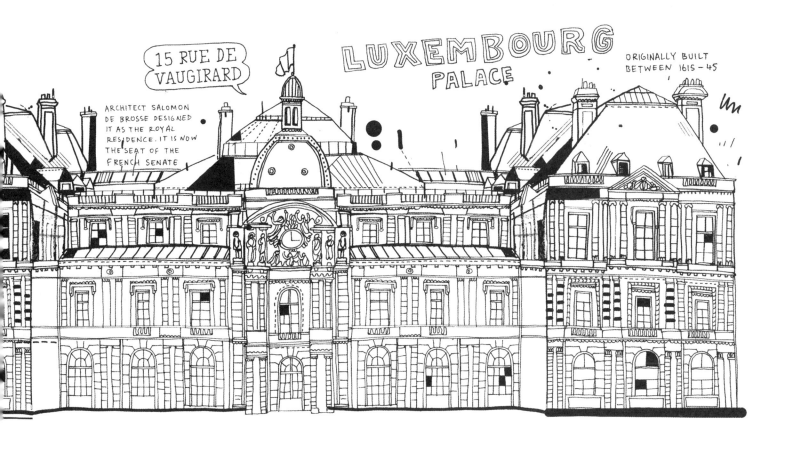

15 RUE DE VAUGIRARD

LUXEMBOURG PALACE

ORIGINALLY BUILT BETWEEN 1615-45

ARCHITECT SALOMON DE BROSSE DESIGNED IT AS THE ROYAL RESIDENCE. IT IS NOW THE SEAT OF THE FRENCH SENATE

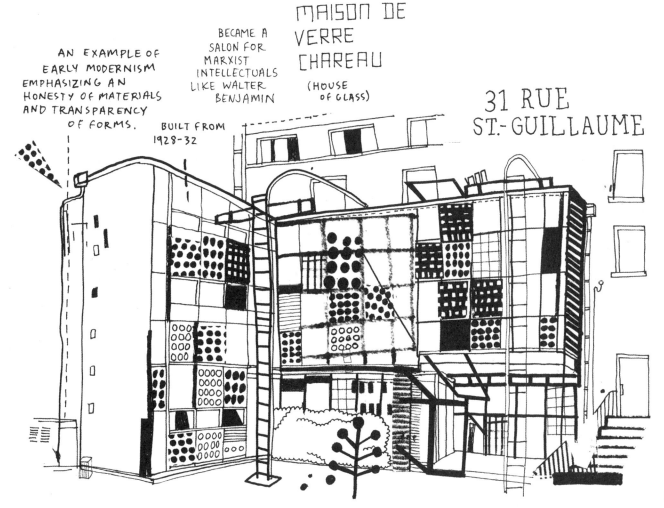

AN EXAMPLE OF EARLY MODERNISM EMPHASIZING AN HONESTY OF MATERIALS AND TRANSPARENCY OF FORMS.

BUILT FROM 1928-32

BECAME A SALON FOR MARXIST INTELLECTUALS LIKE WALTER BENJAMIN

MAISON DE VERRE CHAREAU

(HOUSE OF GLASS)

31 RUE ST.-GUILLAUME

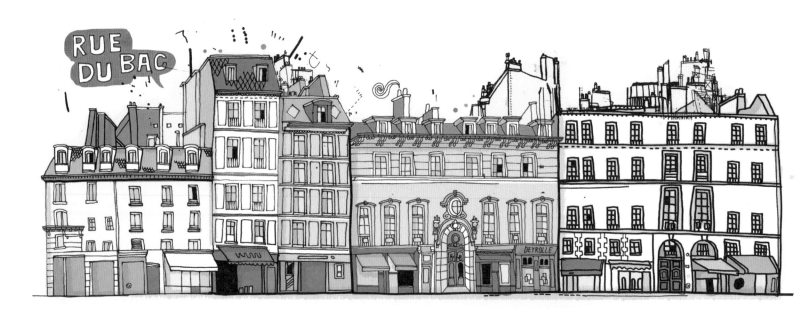

RUE DU BAC

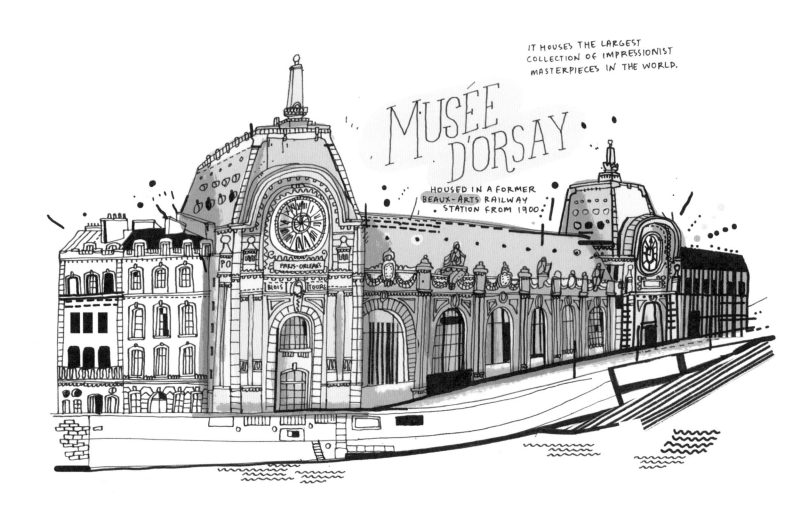

IT HOUSES THE LARGEST COLLECTION OF IMPRESSIONIST MASTERPIECES IN THE WORLD.

MUSÉE D'ORSAY

HOUSED IN A FORMER BEAUX-ARTS RAILWAY STATION FROM 1900.

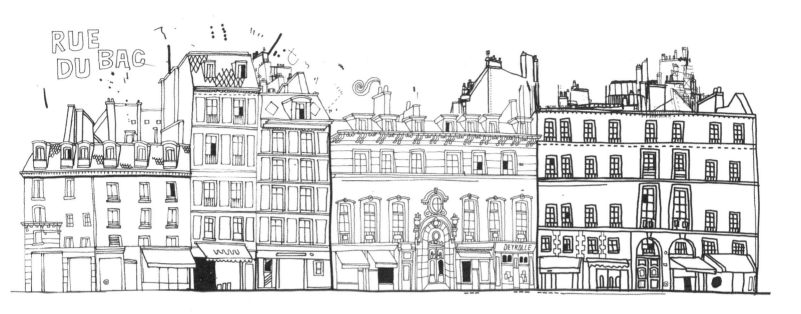

RUE DU BAC

DEYROLLE

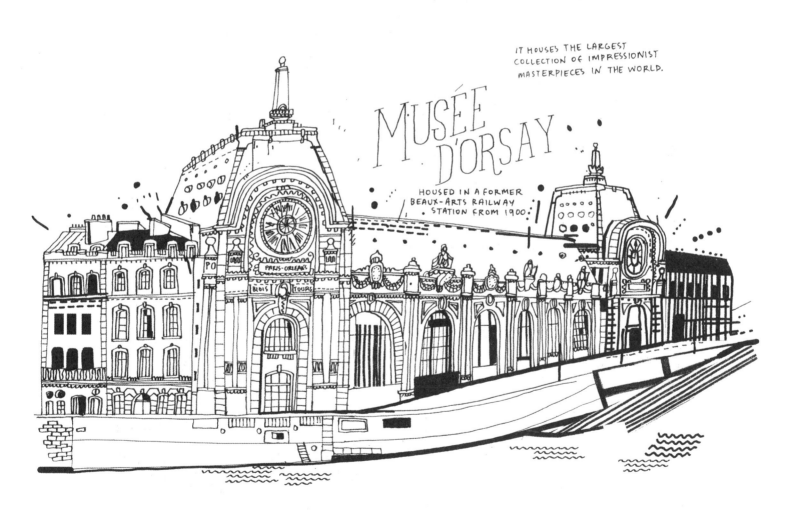

IT HOUSES THE LARGEST COLLECTION OF IMPRESSIONIST MASTERPIECES IN THE WORLD.

MUSÉE D'ORSAY

HOUSED IN A FORMER BEAUX-ARTS RAILWAY STATION FROM 1900.

PARIS-ORLEANS
BLOIS    TOURS

172 BOULEVARD SAINT-GERMAIN

Café de Flore

CAFE DE FLORE

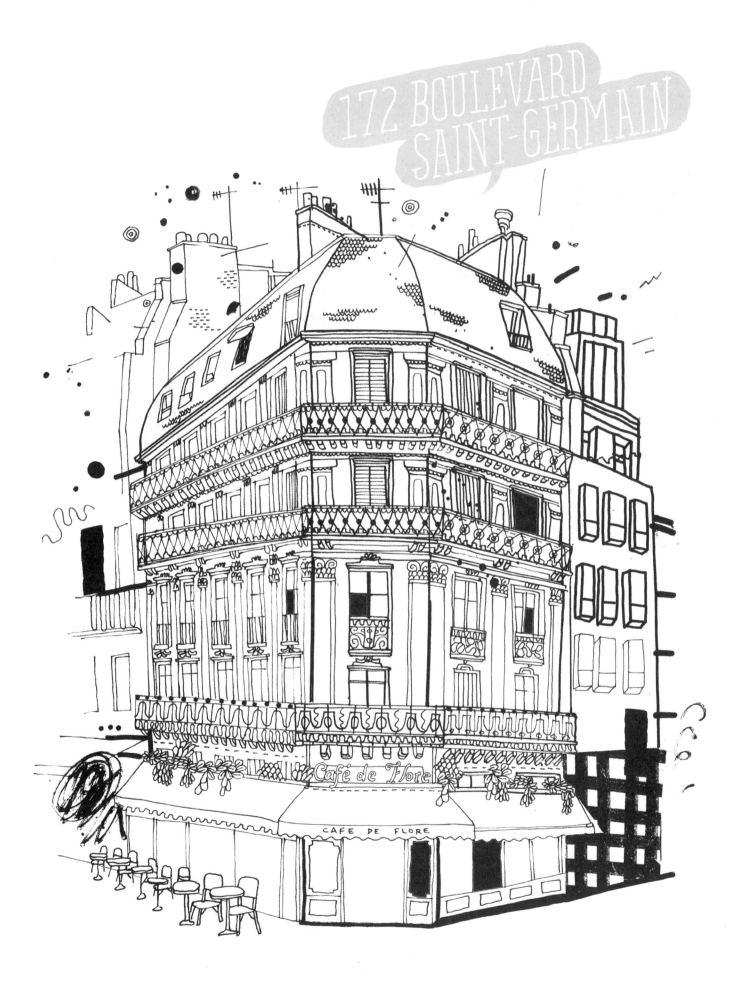

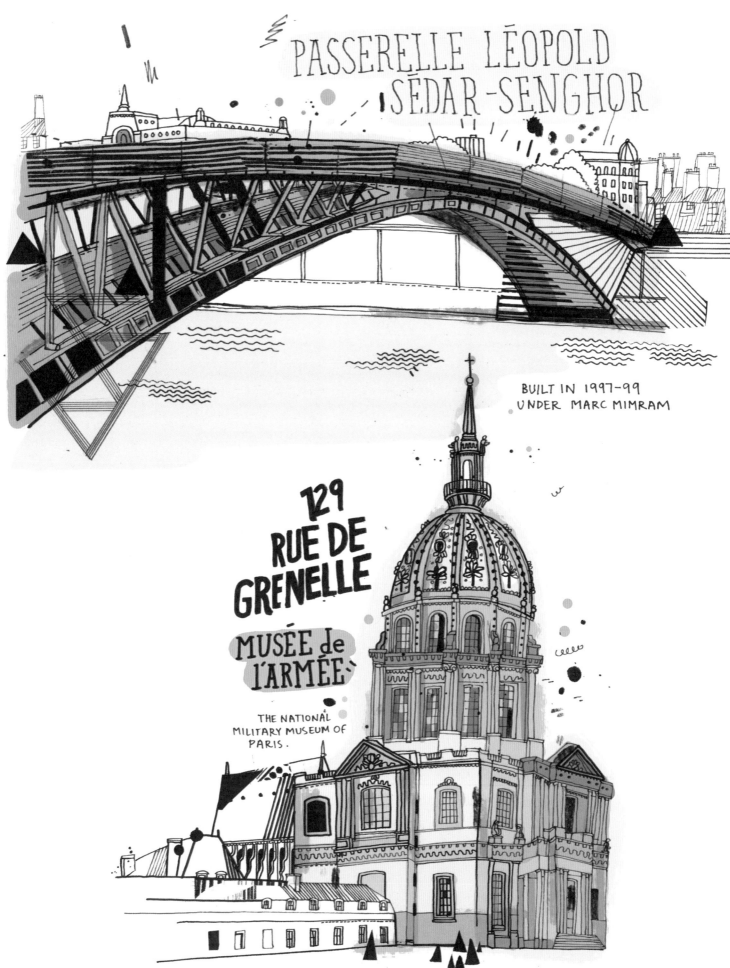

# PASSERELLE LÉOPOLD SÉDAR-SENGHOR

BUILT IN 1997–99
UNDER MARC MIMRAM

## 129 RUE DE GRENELLE

MUSÉE de l'ARMÉE

THE NATIONAL MILITARY MUSEUM OF PARIS.

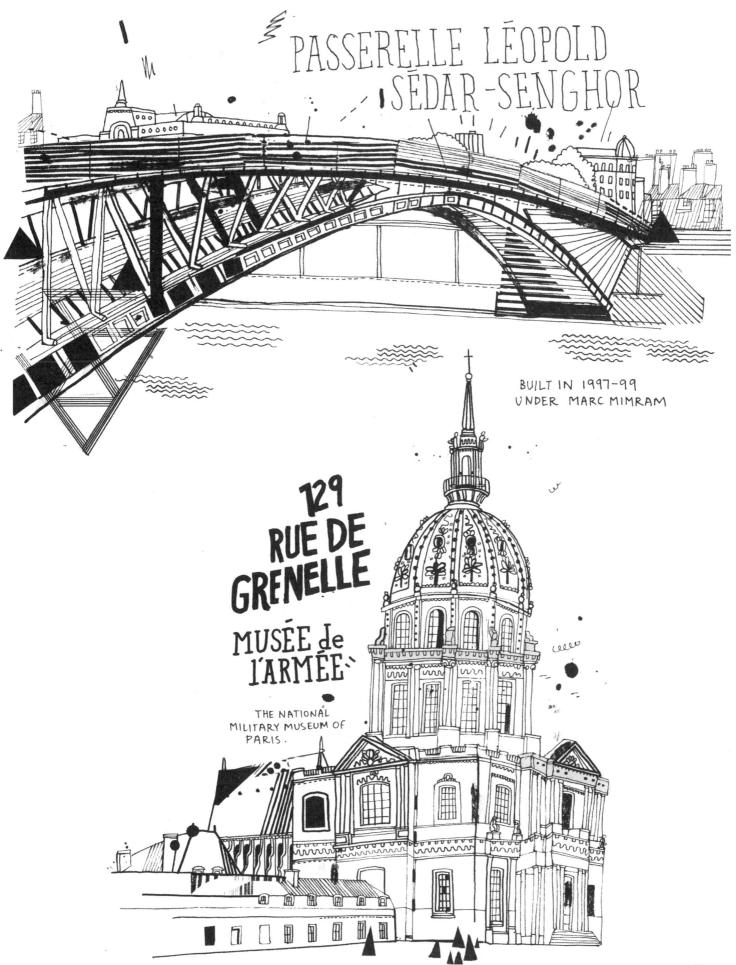

PASSERELLE LÉOPOLD
SÉDAR-SENGHOR

BUILT IN 1997-99
UNDER MARC MIMRAM

129
RUE DE
GRENELLE

MUSÉE de
l'ARMÉE

THE NATIONAL
MILITARY MUSEUM OF
PARIS.

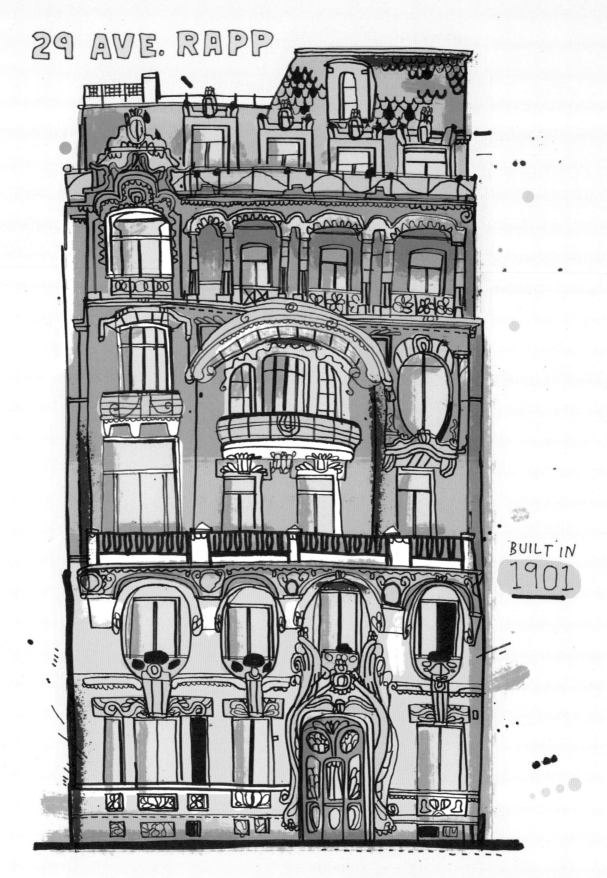

BUILT IN
1901

A FRENCH ARCHITECT KNOWN FOR HIS ART NOUVEAU BUILDINGS

JULES LAVIROTTE
BUILDING

**29 AVE. RAPP**

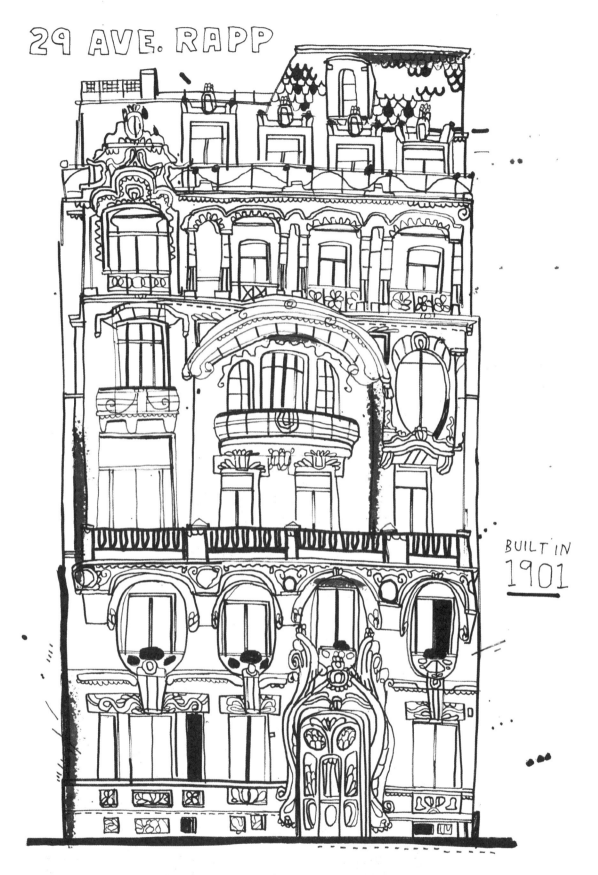

BUILT IN
1901

A FRENCH ARCHITECT KNOWN FOR HIS ART NOUVEAU BUILDINGS

## JULES LAVIROTTE
BUILDING

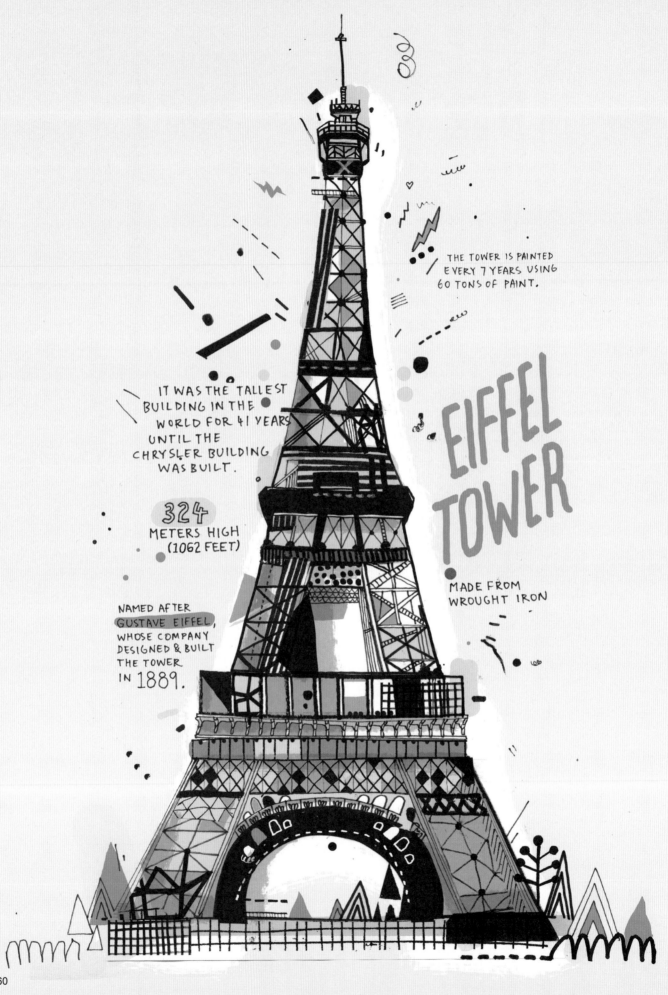

THE TOWER IS PAINTED EVERY 7 YEARS USING 60 TONS OF PAINT.

IT WAS THE TALLEST BUILDING IN THE WORLD FOR 41 YEARS UNTIL THE CHRYSLER BUILDING WAS BUILT.

**324** METERS HIGH (1062 FEET)

NAMED AFTER GUSTAVE EIFFEL, WHOSE COMPANY DESIGNED & BUILT THE TOWER IN 1889.

EIFFEL TOWER

MADE FROM WROUGHT IRON

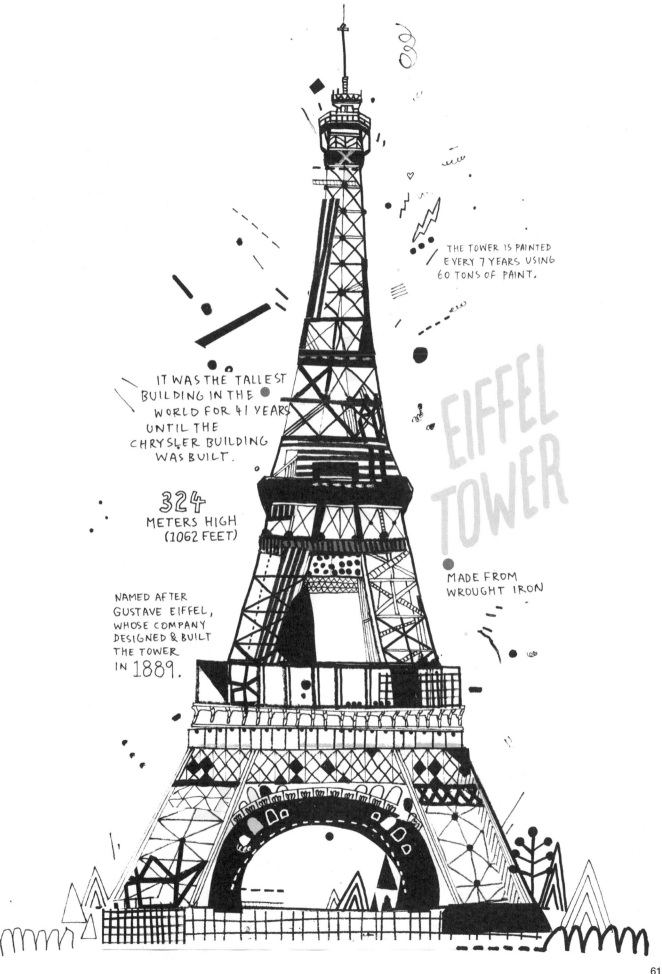

THE TOWER IS PAINTED EVERY 7 YEARS USING 60 TONS OF PAINT.

IT WAS THE TALLEST BUILDING IN THE WORLD FOR 41 YEARS UNTIL THE CHRYSLER BUILDING WAS BUILT.

324 METERS HIGH (1062 FEET)

NAMED AFTER GUSTAVE EIFFEL, WHOSE COMPANY DESIGNED & BUILT THE TOWER IN 1889.

EIFFEL TOWER

MADE FROM WROUGHT IRON

RODIN USED THE BUILDING AS HIS WORKSHOP AND DONATED HIS AND OTHER ARTIST'S WORKS TO THE STATE.

THE THINKER IS HERE AS WELL AS WORKS BY MONET, RENOIR AND VAN GOGH

# MUSÉE RODIN

79 RUE DE VARENNE

OPENED IN 1919 DEDICATED TO THE WORKS OF AUGUSTE RODIN.

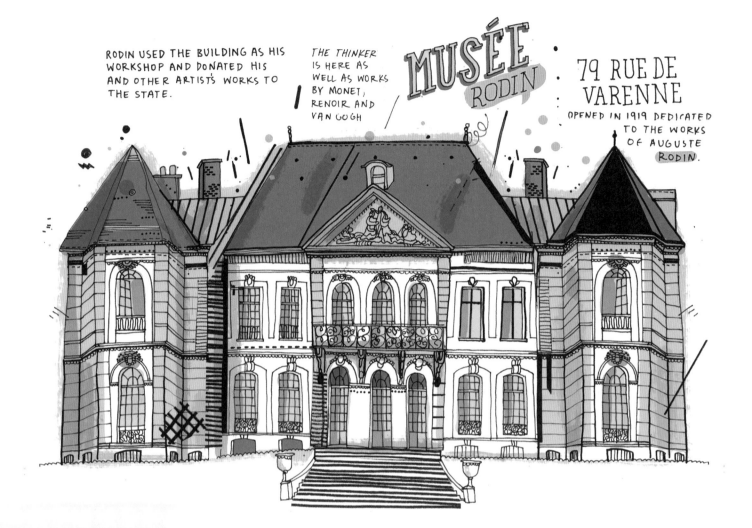

# THÉÂTRE DES CHAMPS-ÉLYSÉES

DESIGNED BY AUGUSTE PERRET

BUILT FROM REINFORCED CONCRETE IN THE ART DECO STYLE...

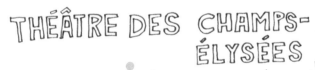

15 AVENUE MONTAIGNE

OPENED IN 1913

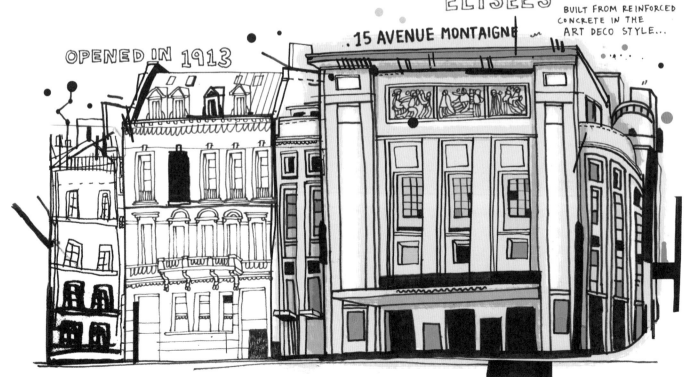

RODIN USED THE BUILDING AS HIS WORKSHOP AND DONATED HIS AND OTHER ARTIST'S WORKS TO THE STATE.

THE THINKER IS HERE AS WELL AS WORKS BY MONET, RENOIR AND VAN GOGH

# MUSÉE RODIN

## 79 RUE DE VARENNE

OPENED IN 1919 DEDICATED TO THE WORKS OF AUGUSTE RODIN.

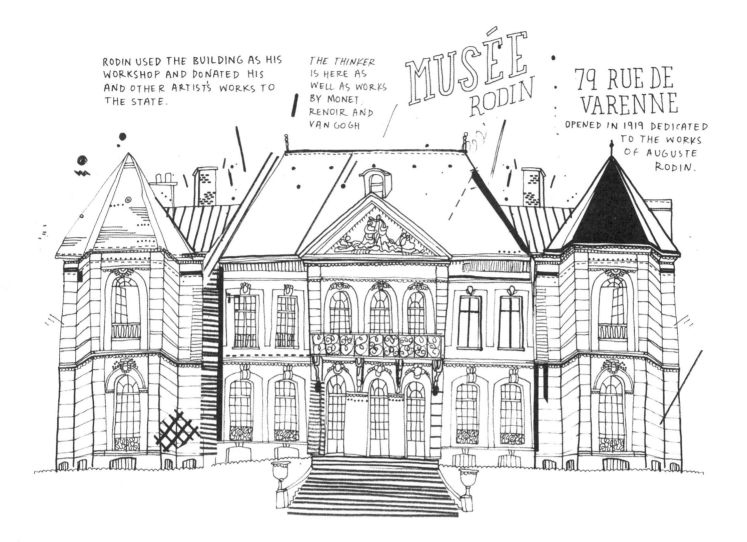

# THÉÂTRE DES CHAMPS-ÉLYSÉES

DESIGNED BY AUGUSTE PERRET

BUILT FROM REINFORCED CONCRETE IN THE ART DECO STYLE...

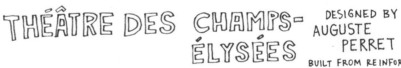

15 AVENUE MONTAIGNE

OPENED IN 1913

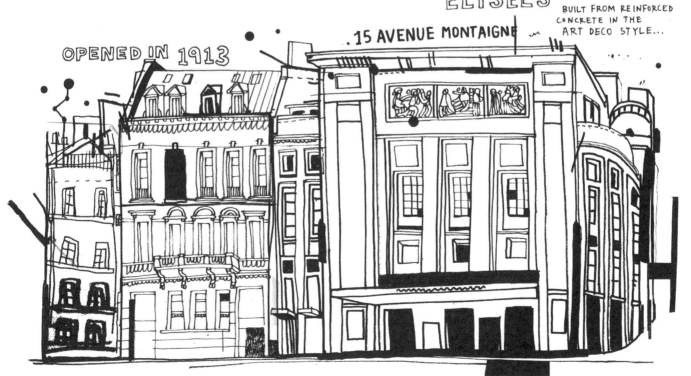

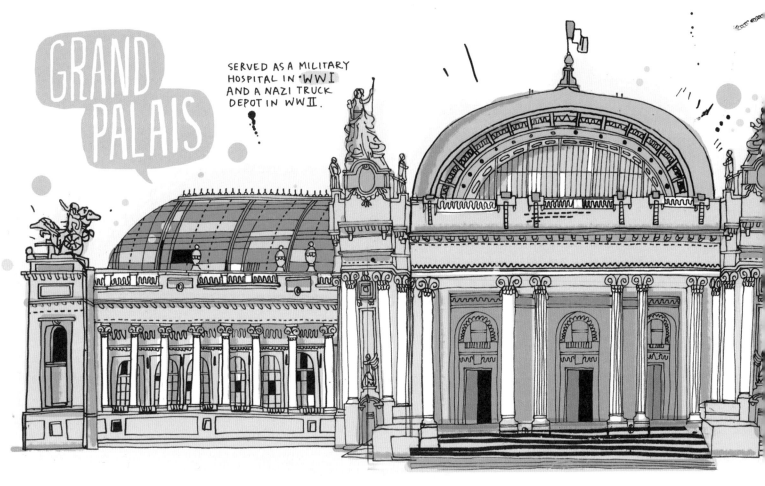

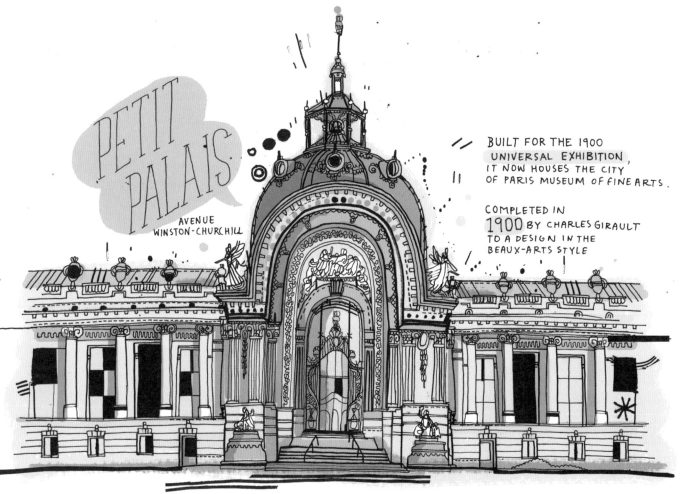

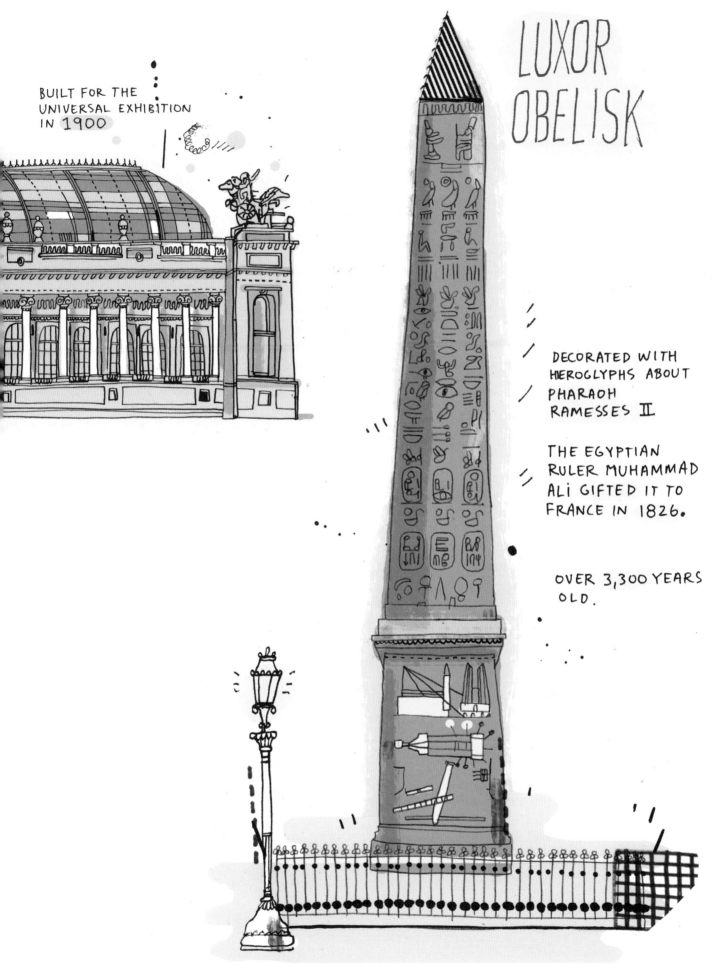

BUILT FOR THE UNIVERSAL EXHIBITION IN 1900

# LUXOR OBELISK

DECORATED WITH HIEROGLYPHS ABOUT PHARAOH RAMESSES II

THE EGYPTIAN RULER MUHAMMAD ALI GIFTED IT TO FRANCE IN 1826.

OVER 3,300 YEARS OLD.

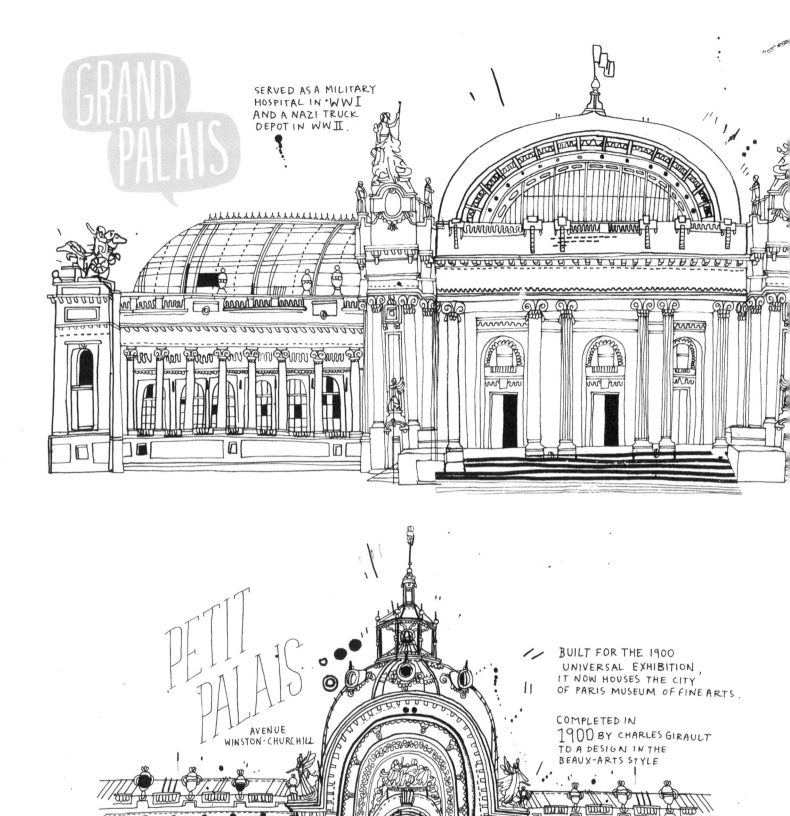

GRAND PALAIS

SERVED AS A MILITARY HOSPITAL IN WWI AND A NAZI TRUCK DEPOT IN WWII.

PETIT PALAIS

AVENUE WINSTON-CHURCHILL

BUILT FOR THE 1900 UNIVERSAL EXHIBITION, IT NOW HOUSES THE CITY OF PARIS MUSEUM OF FINE ARTS.

COMPLETED IN 1900 BY CHARLES GIRAULT TO A DESIGN IN THE BEAUX-ARTS STYLE

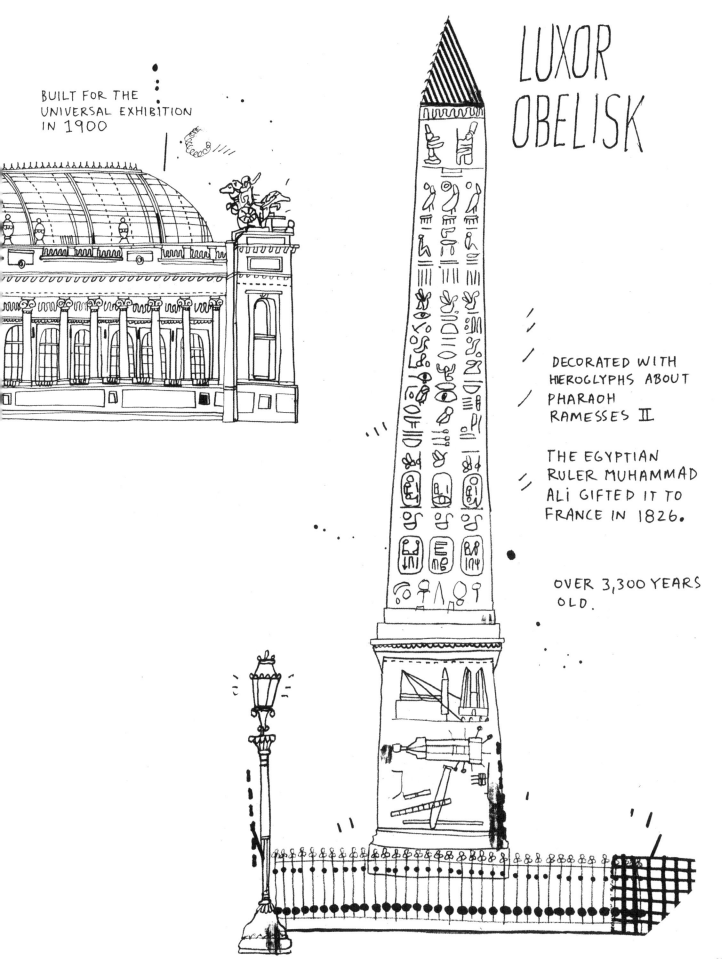

BUILT FOR THE UNIVERSAL EXHIBITION IN 1900

# LUXOR OBELISK

DECORATED WITH HIEROGLYPHS ABOUT PHARAOH RAMESSES II

THE EGYPTIAN RULER MUHAMMAD ALI GIFTED IT TO FRANCE IN 1826.

OVER 3,300 YEARS OLD.

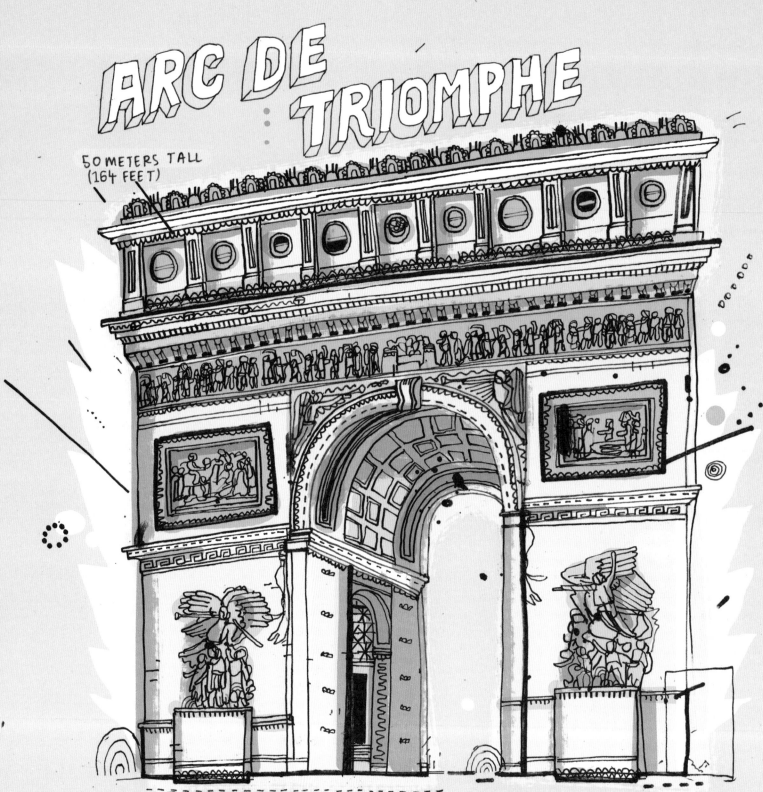

# ARC DE TRIOMPHE

50 METERS TALL
(164 FEET)

BENEATH IS THE
TOMB OF THE
UNKNOWN
SOLDIER.

HONORS THOSE WHO FOUGHT AND DIED
FOR FRANCE IN THE FRENCH REVOLUTIONARY
AND NAPOLEONIC WARS.

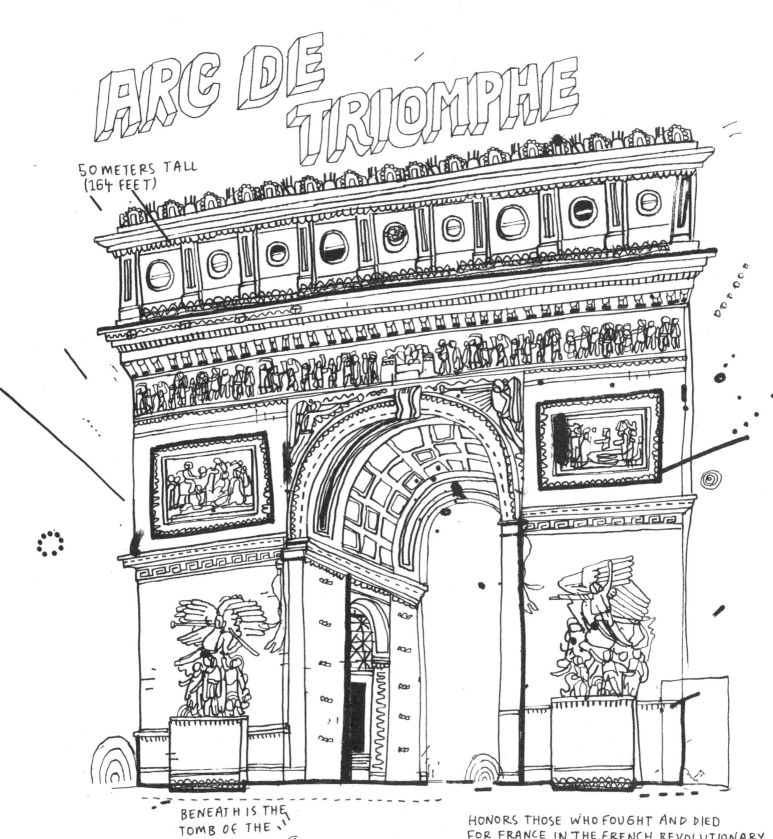

# ARC DE TRIOMPHE

50 METERS TALL
(164 FEET)

BENEATH IS THE
TOMB OF THE
UNKNOWN
SOLDIER.

HONORS THOSE WHO FOUGHT AND DIED
FOR FRANCE IN THE FRENCH REVOLUTIONARY
AND NAPOLEONIC WARS.

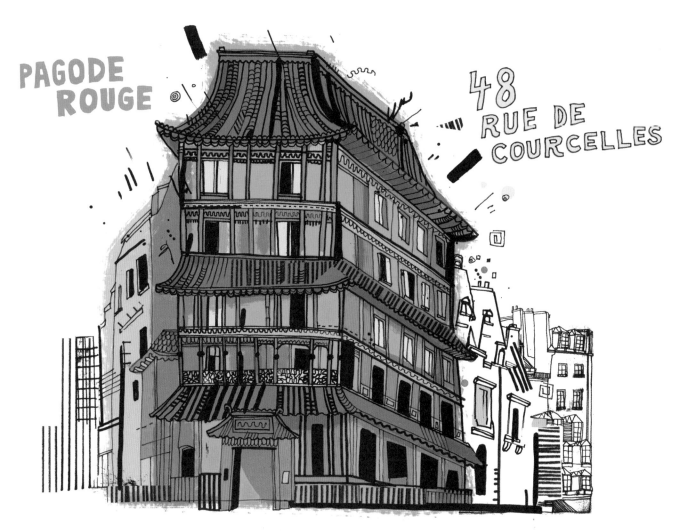

PAGODE ROUGE

48 RUE DE COURCELLES

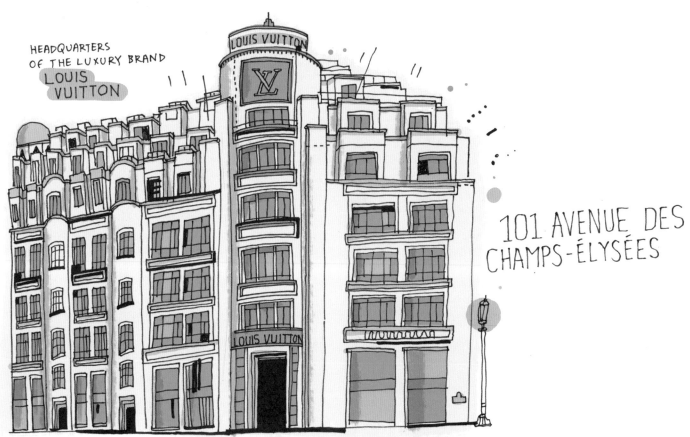

HEADQUARTERS OF THE LUXURY BRAND LOUIS VUITTON

LOUIS VUITTON

LV

LOUIS VUITTON

101 AVENUE DES CHAMPS-ÉLYSÉES

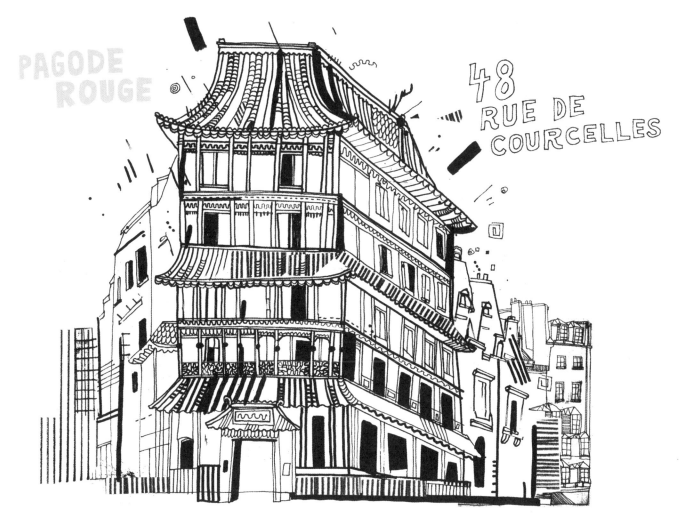

PAGODE
ROUGE

48
RUE DE
COURCELLES

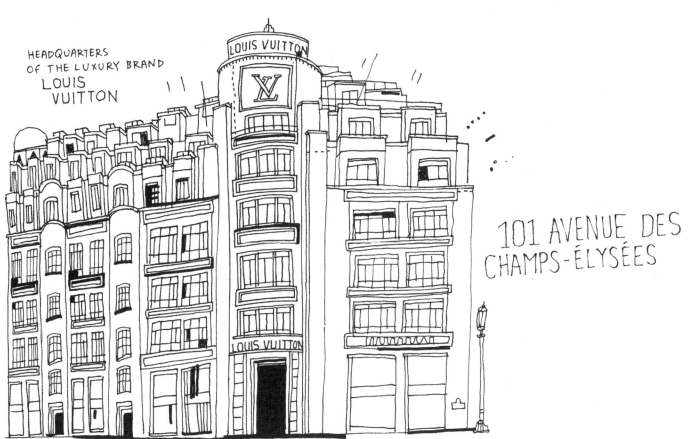

HEADQUARTERS
OF THE LUXURY BRAND
LOUIS
VUITTON

LOUIS VUITTON

LV

LOUIS VUITTON

101 AVENUE DES
CHAMPS-ÉLYSÉES

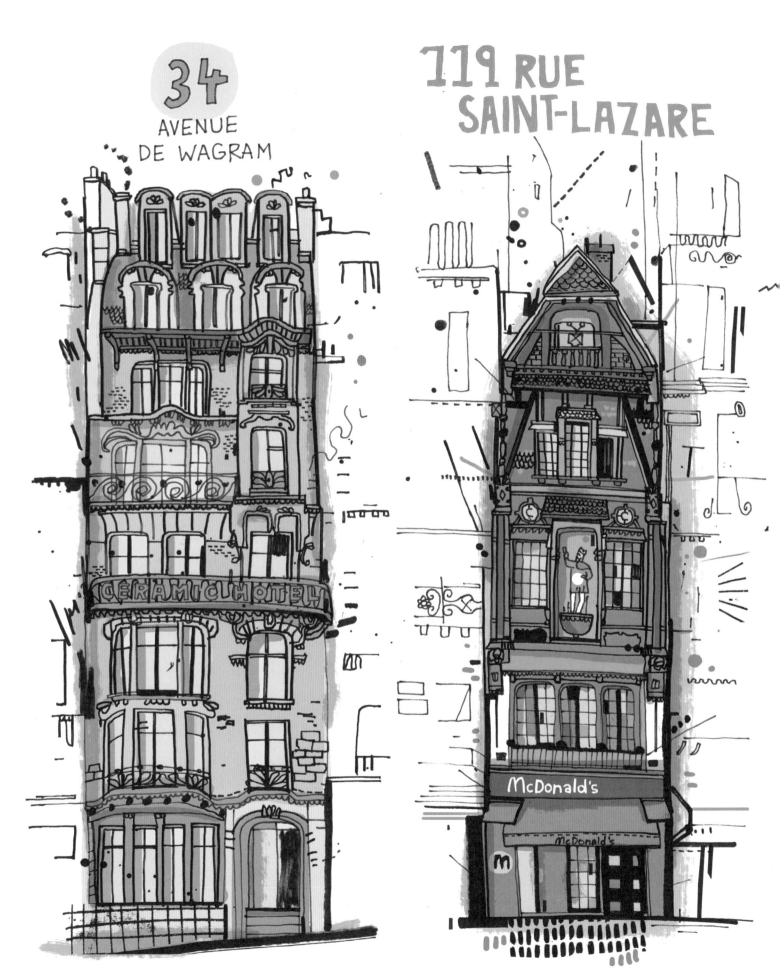

# 34
AVENUE DE WAGRAM

CERAMIC HOTEL

# 119 RUE SAINT-LAZARE

McDonald's

McDonald's

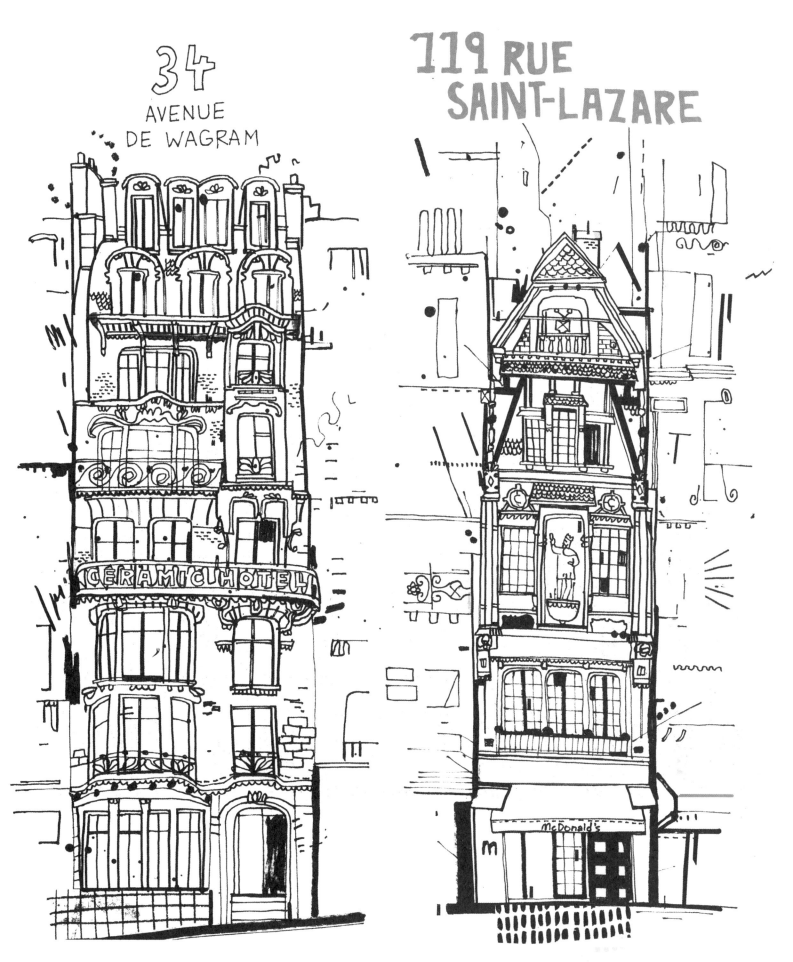

# 34
AVENUE
DE WAGRAM

# 119 RUE
SAINT-LAZARE

CÉRAMIC HOTEL

McDonald's

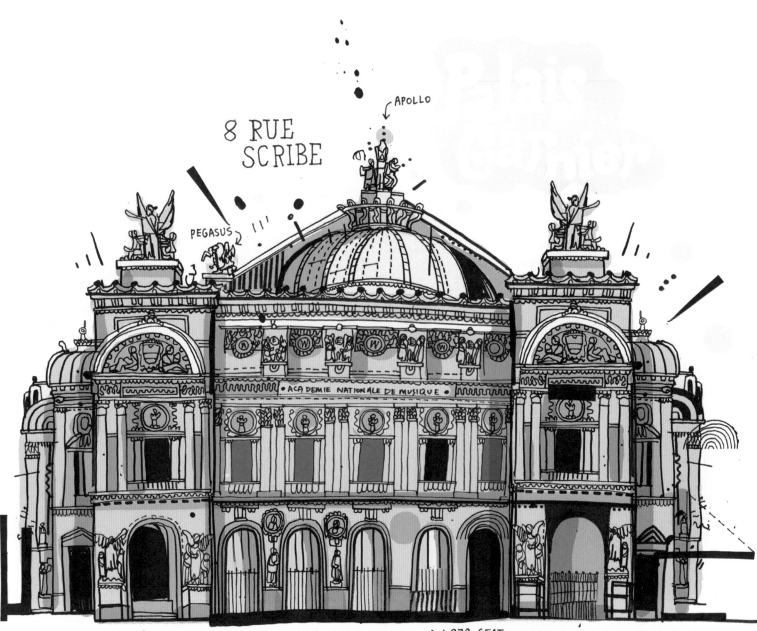

8 RUE
SCRIBE

APOLLO

PEGASUS

ACADEMIE NATIONALE DE MUSIQUE

A 1,979-SEAT
OPERA HOUSE
BUILT FROM
1861-75

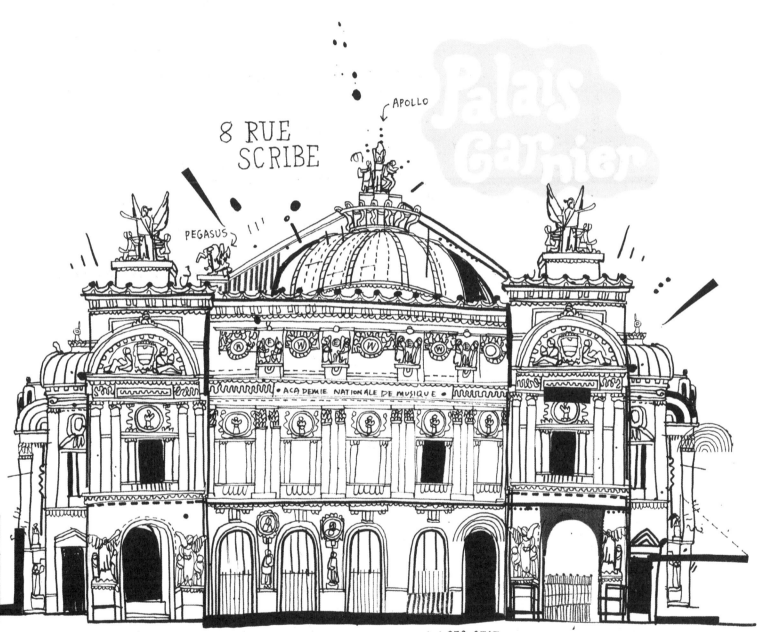

8 RUE
SCRIBE

APOLLO

PEGASUS

Palais Garnier

• ACADEMIE NATIONALE DE MUSIQUE •

A 1,979-SEAT
OPERA HOUSE
BUILT FROM
1861-75

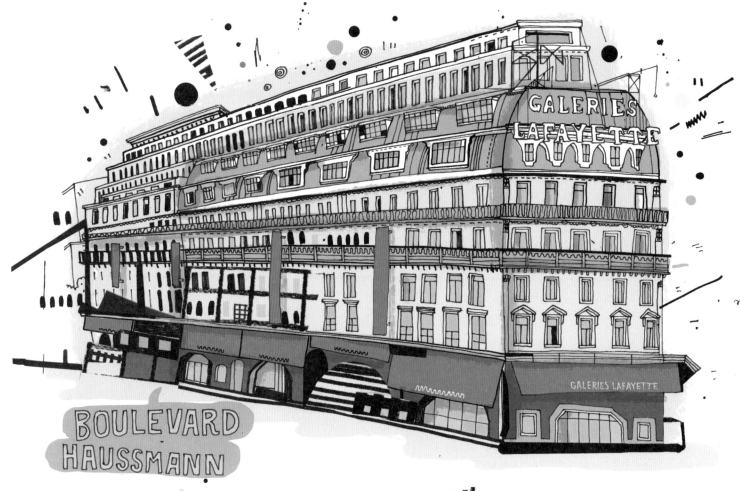

BOULEVARD HAUSSMANN

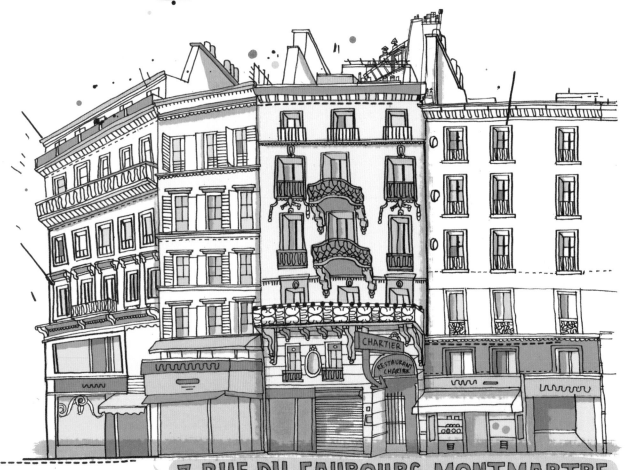

7 RUE DU FAUBOURG MONTMARTRE

BOULEVARD HAUSSMANN

7 RUE DU FAUBOURG MONTMARTRE

# 32 RUE RICHER

A CABARET MUSIC HALL ESTABLISHED IN 1869

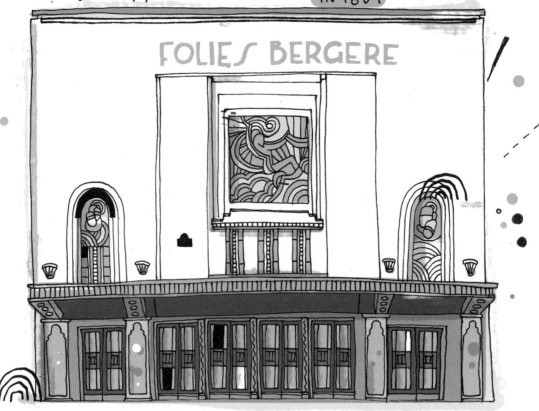

FOLIES BERGERE

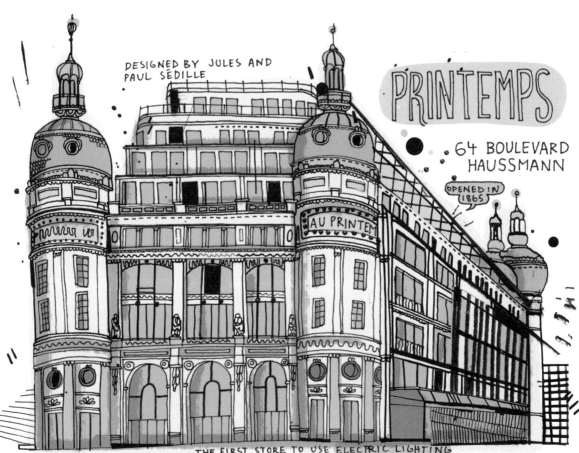

DESIGNED BY JULES AND PAUL SÉDILLE

PRINTEMPS

64 BOULEVARD HAUSSMANN

OPENED IN 1865

AU PRINTEM

THE FIRST STORE TO USE ELECTRIC LIGHTING AND TO BE DIRECTLY CONNECTED TO THE SUBWAY

# 32 RUE RICHER

A CABARET MUSIC HALL ESTABLISHED IN 1869

FOLIES BERGERE

DESIGNED BY JULES AND PAUL SÉDILLE

PRINTEMPS

64 BOULEVARD HAUSSMANN

OPENED IN 1865

AU PRINTEM

THE FIRST STORE TO USE ELECTRIC LIGHTING AND TO BE DIRECTLY CONNECTED TO THE SUBWAY

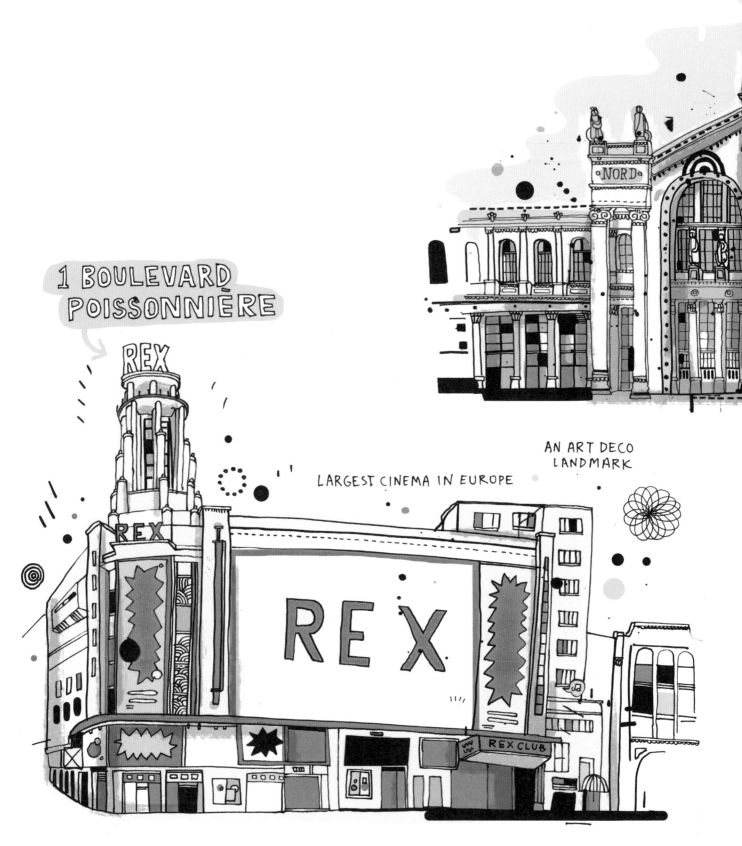

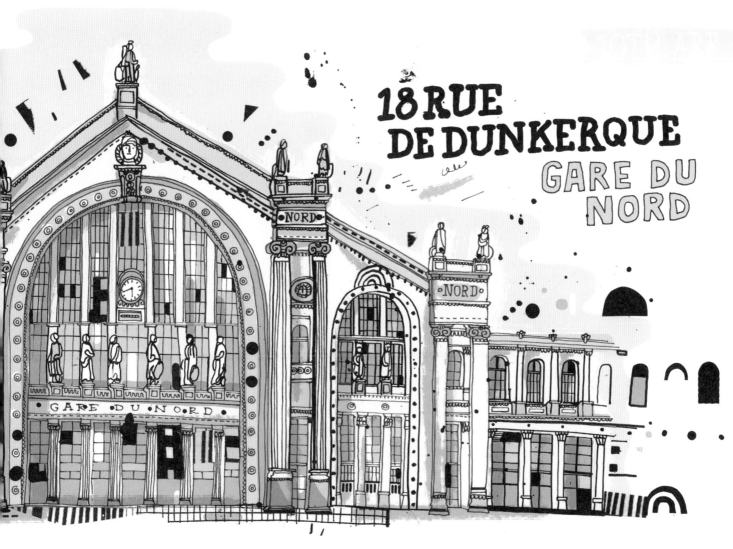

# 18 RUE DE DUNKERQUE

## GARE DU NORD

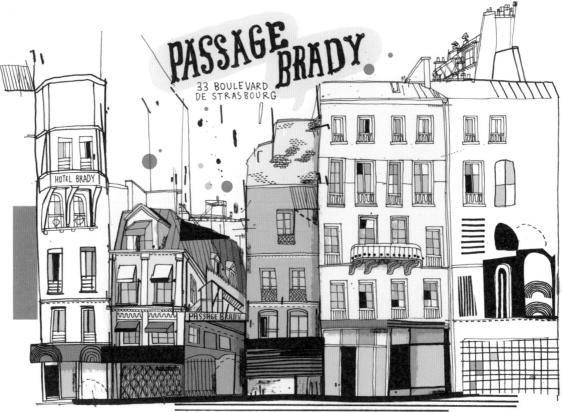

# PASSAGE BRADY

33 BOULEVARD DE STRASBOURG

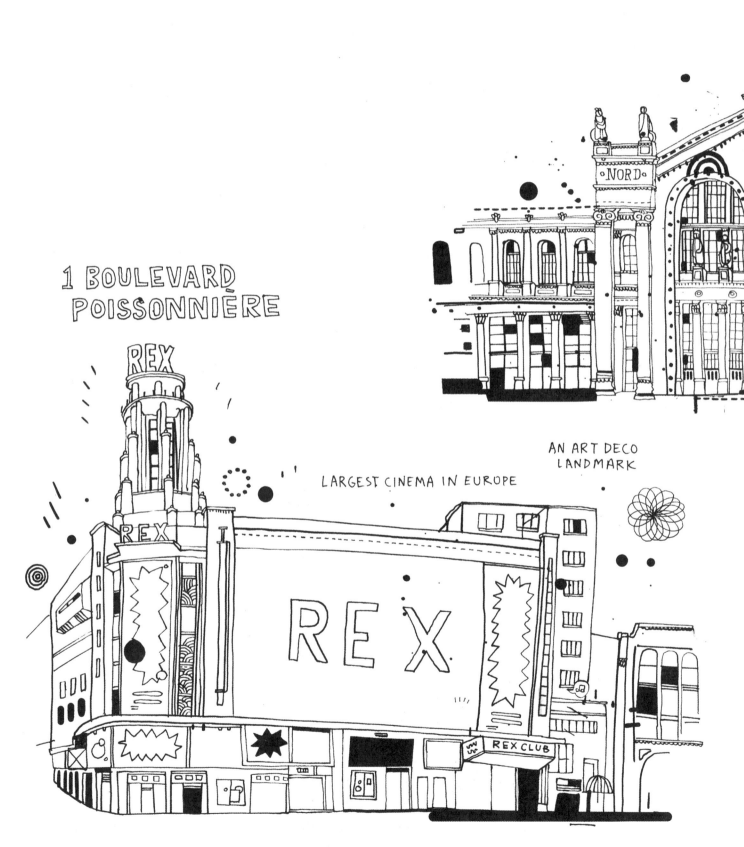

1 BOULEVARD POISSONNIÈRE

AN ART DECO LANDMARK

LARGEST CINEMA IN EUROPE

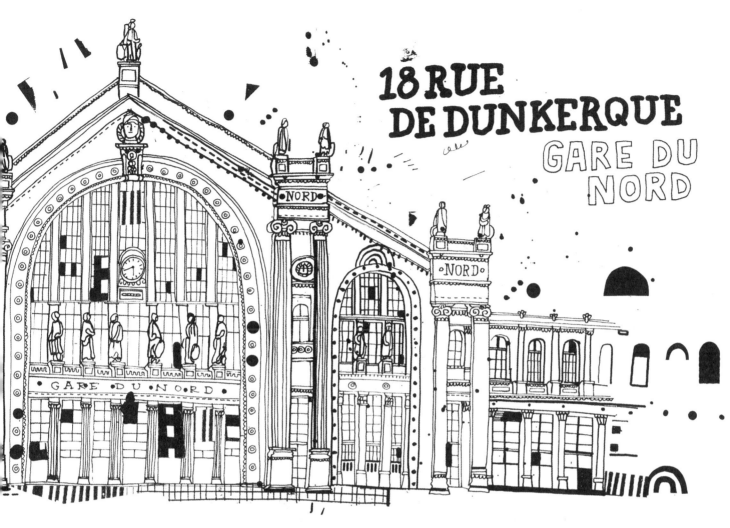

# 18 RUE DE DUNKERQUE

## GARE DU NORD

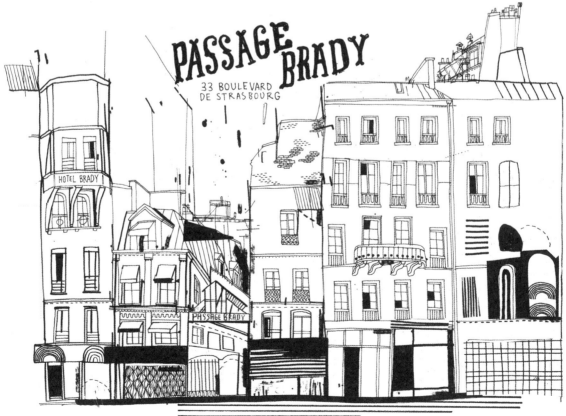

# PASSAGE BRADY

33 BOULEVARD
DE STRASBOURG

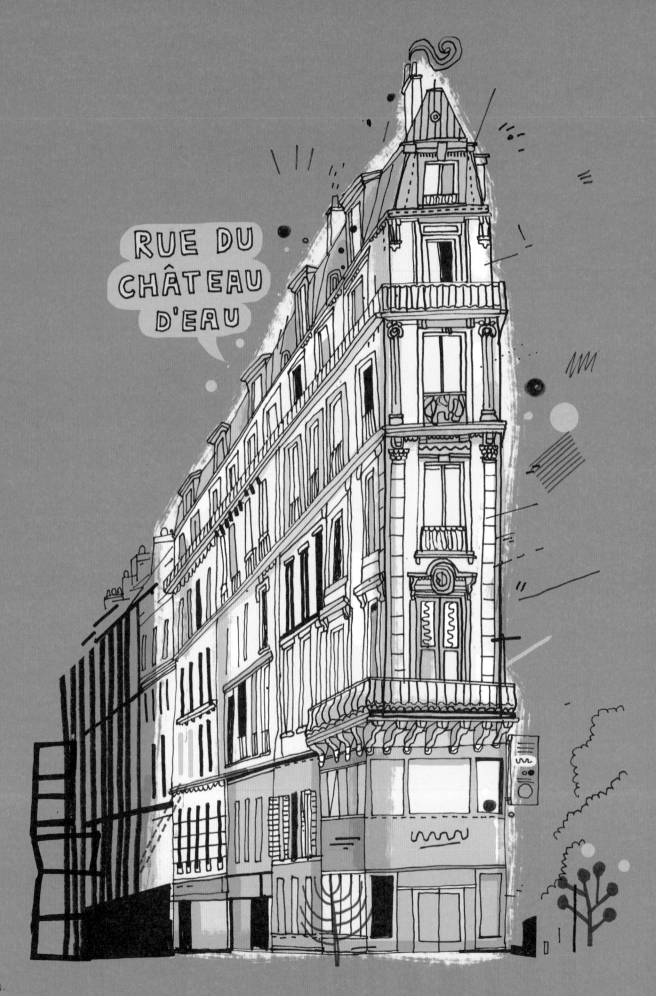

RUE DU CHÂTEAU D'EAU

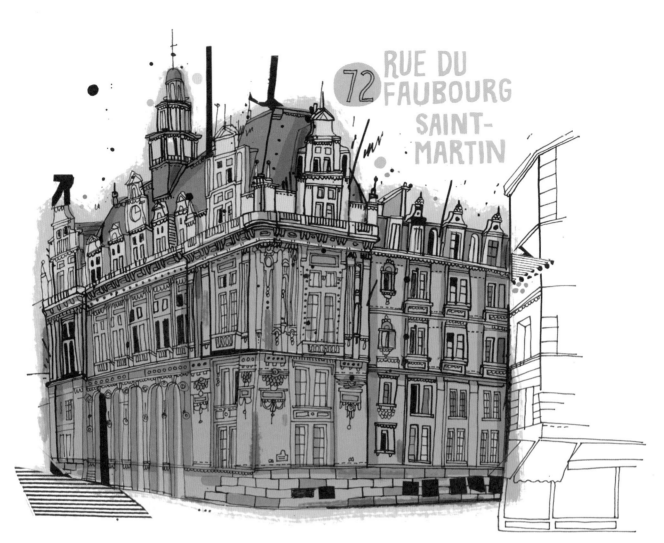

72 RUE DU FAUBOURG SAINT-MARTIN

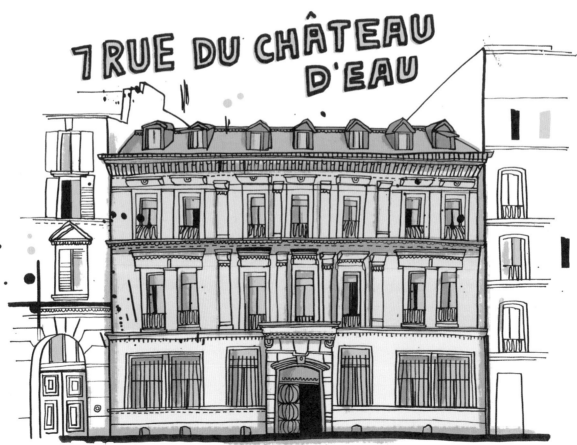

7 RUE DU CHÂTEAU D'EAU

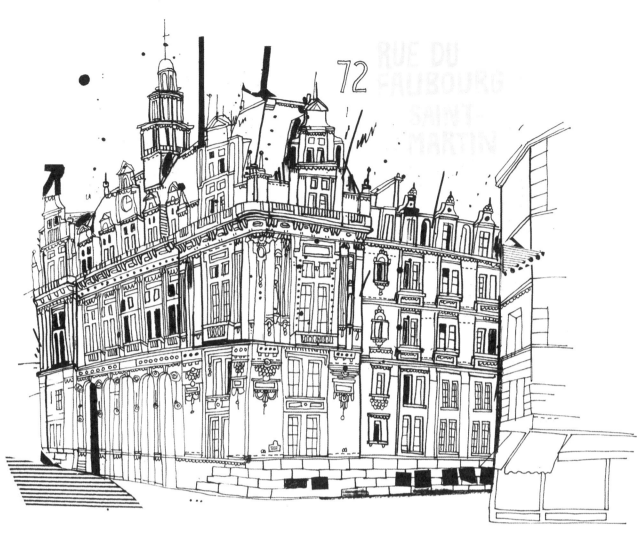

72 RUE DU FAUBOURG SAINT-MARTIN

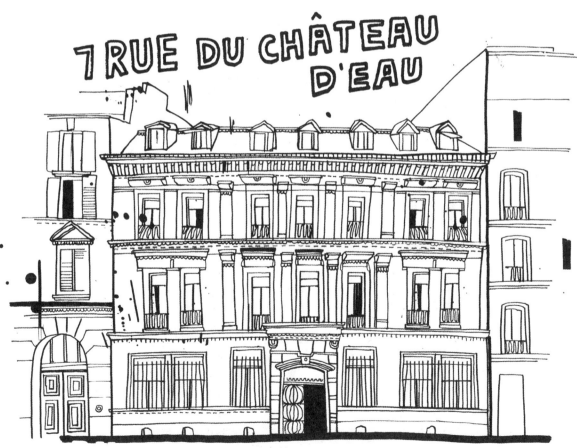

7 RUE DU CHÂTEAU D'EAU

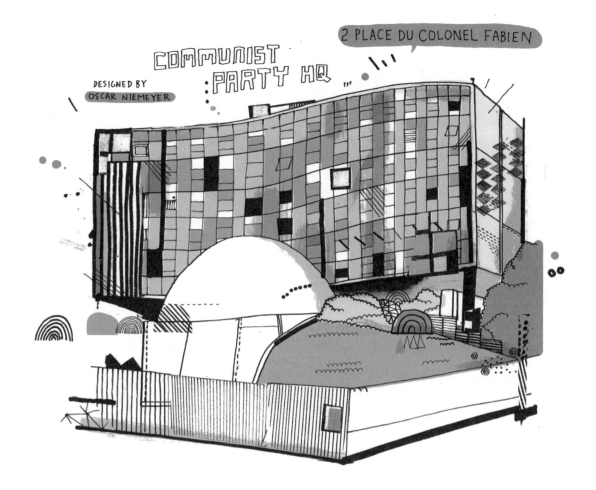

COMMUNIST PARTY HQ

2 PLACE DU COLONEL FABIEN

DESIGNED BY OSCAR NIEMEYER

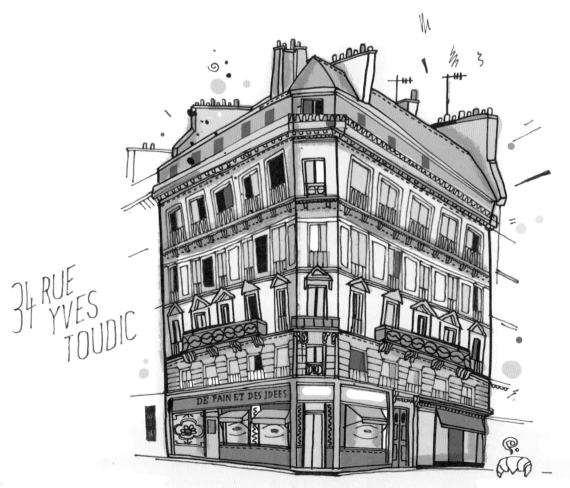

34 RUE YVES TOUDIC

DE PAIN ET DES IDEES

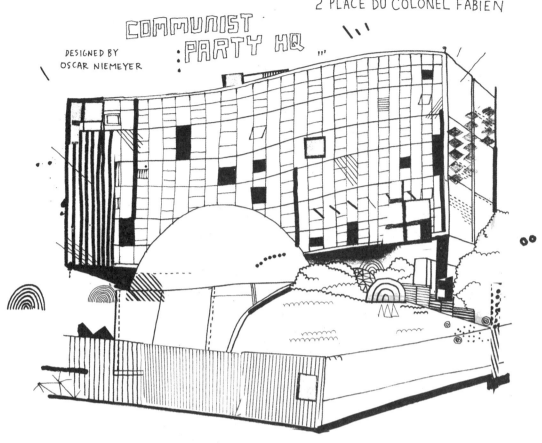

COMMUNIST PARTY HQ

2 PLACE DU COLONEL FABIEN

DESIGNED BY OSCAR NIEMEYER

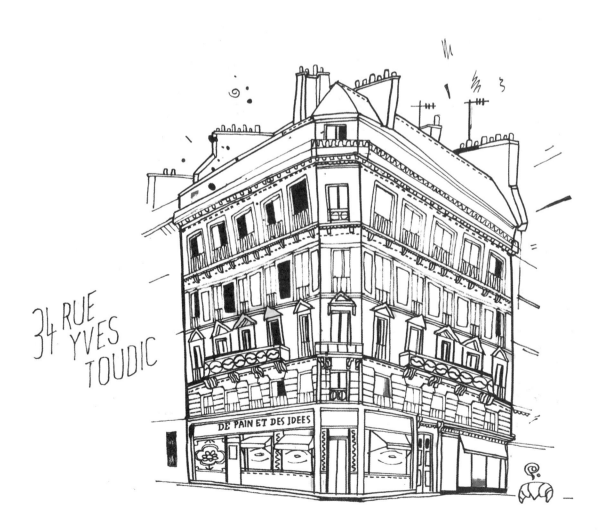

34 RUE YVES TOUDIC

DE PAIN ET DES IDEES

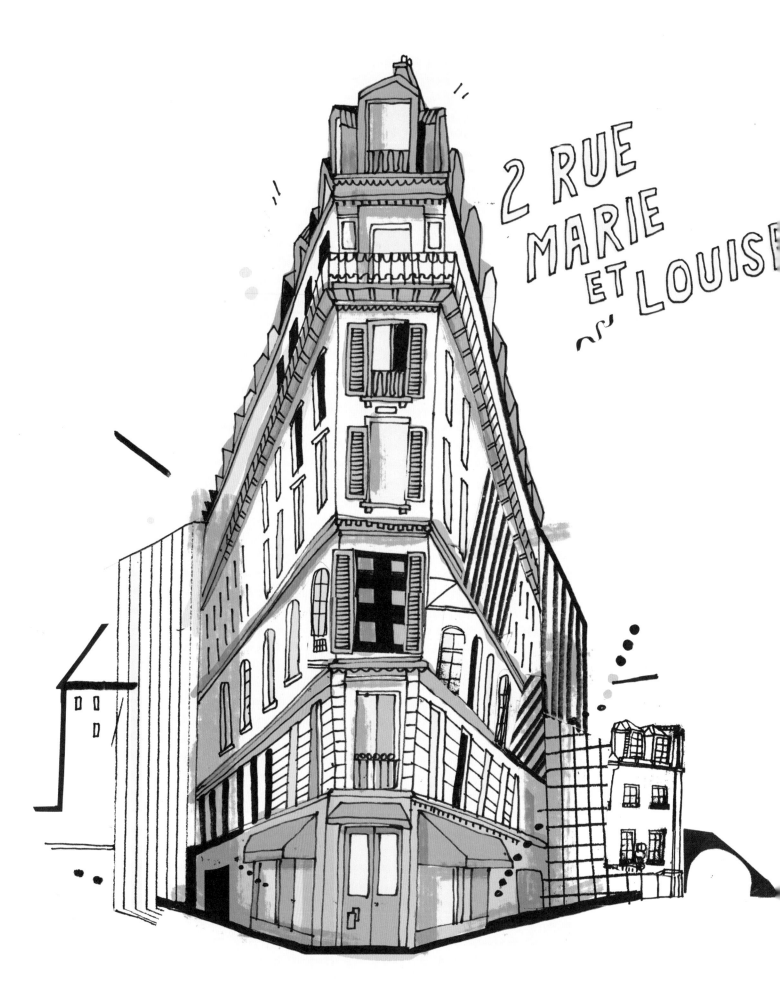

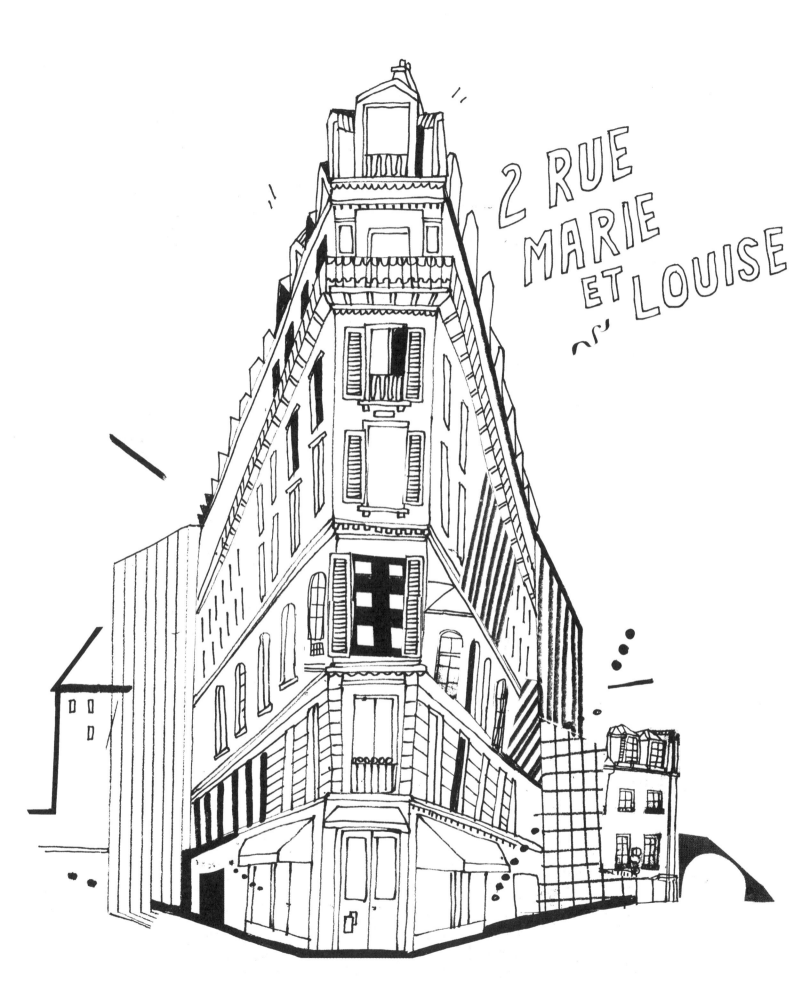

2 RUE MARIE ET LOUISE

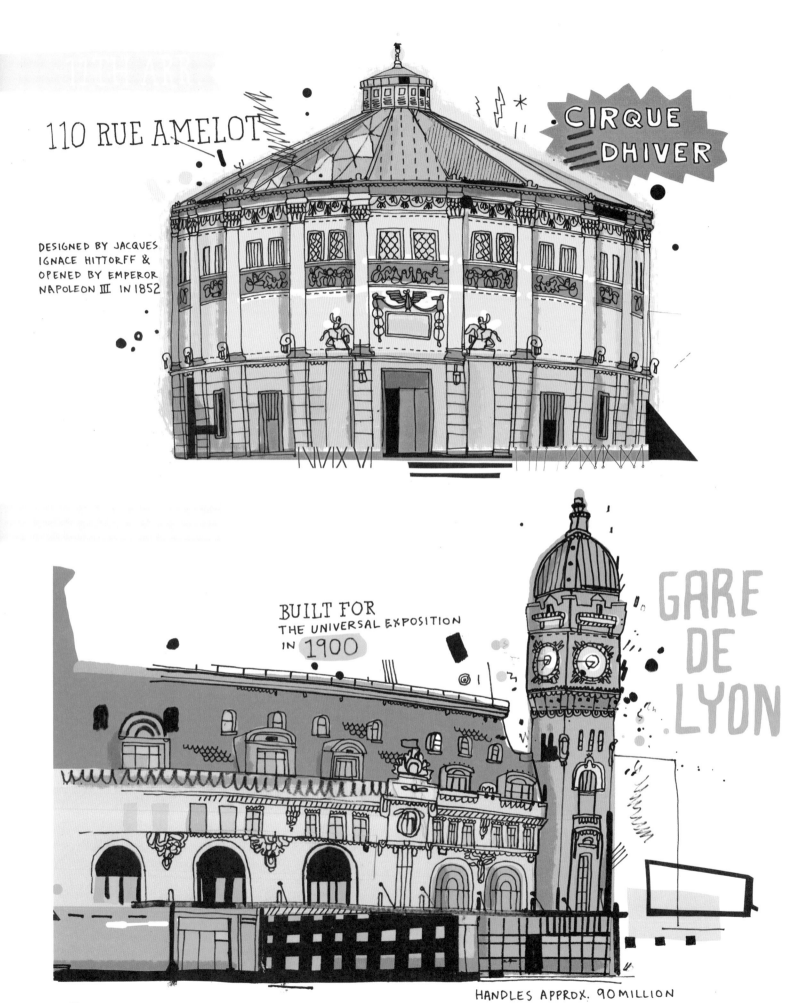

110 RUE AMELOT

CIRQUE DHIVER

DESIGNED BY JACQUES IGNACE HITTORFF & OPENED BY EMPEROR NAPOLEON III IN 1852

BUILT FOR THE UNIVERSAL EXPOSITION IN 1900

GARE DE LYON

HANDLES APPROX. 90 MILLION PASSENGERS PER YEAR.

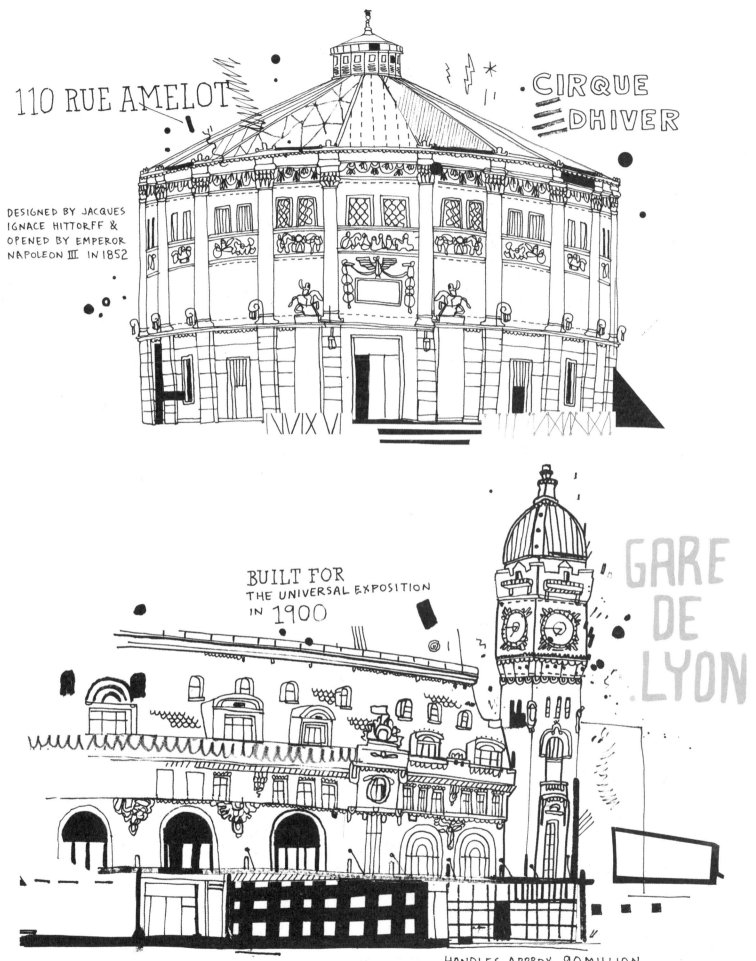

110 RUE AMELOT

CIRQUE DHIVER

DESIGNED BY JACQUES IGNACE HITTORFF & OPENED BY EMPEROR NAPOLEON III IN 1852

IVIX VI

BUILT FOR THE UNIVERSAL EXPOSITION IN 1900

GARE DE LYON

HANDLES APPROX. 90 MILLION PASSENGERS PER YEAR.

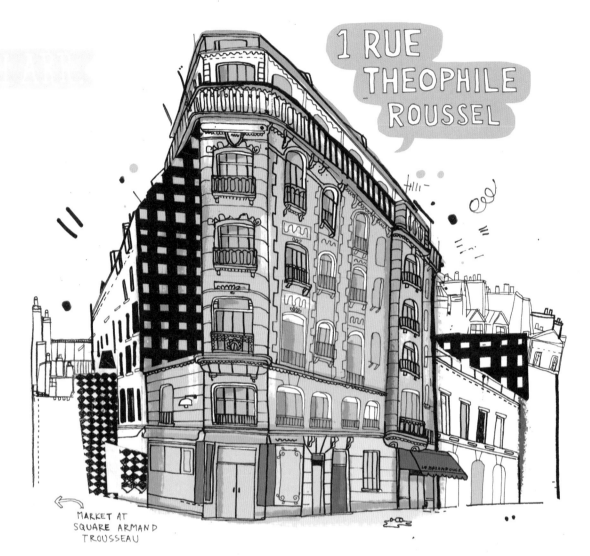

1 RUE
THEOPHILE
ROUSSEL

← MARKET AT
SQUARE ARMAND
TROUSSEAU

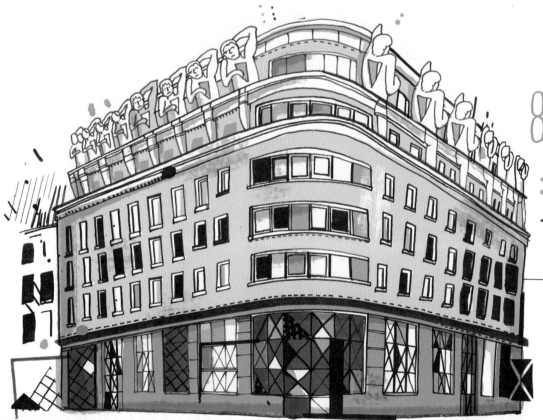

80 AVENUE
DAUMESNIL

POLICE HQ FOR
THE 12TH ARRONDISSEMENT

DESIGNED IN 1991
THE FIGURES ON THE TOP
ARE REPLICAS OF MICHELANGELO'S
"THE DYING SLAVE."

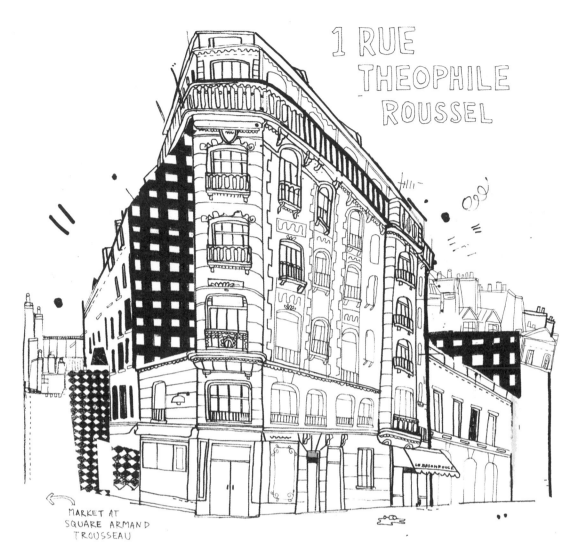

1 RUE
THEOPHILE
ROUSSEL

MARKET AT
SQUARE ARMAND
TROUSSEAU

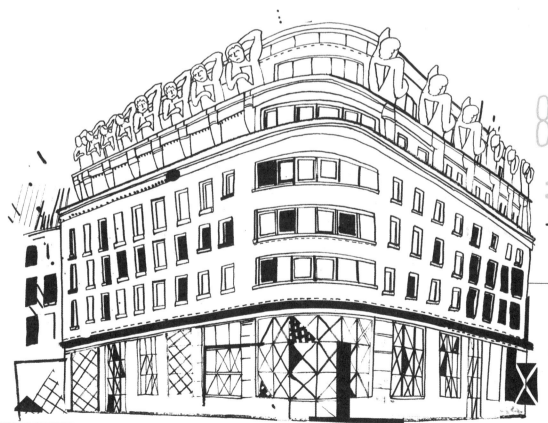

80 AVENUE
= DAUMESNIL

POLICE HQ FOR
THE 12TH ARRONDISSEMENT

DESIGNED IN 1991
THE FIGURES ON THE TOP
ARE REPLICAS OF MICHELANGELO'S
"THE DYING SLAVE"

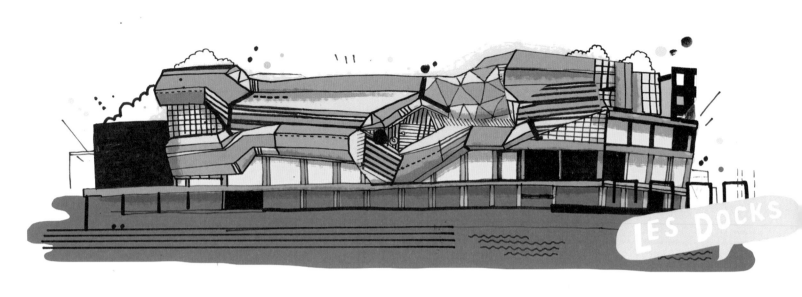

LES DOCKS

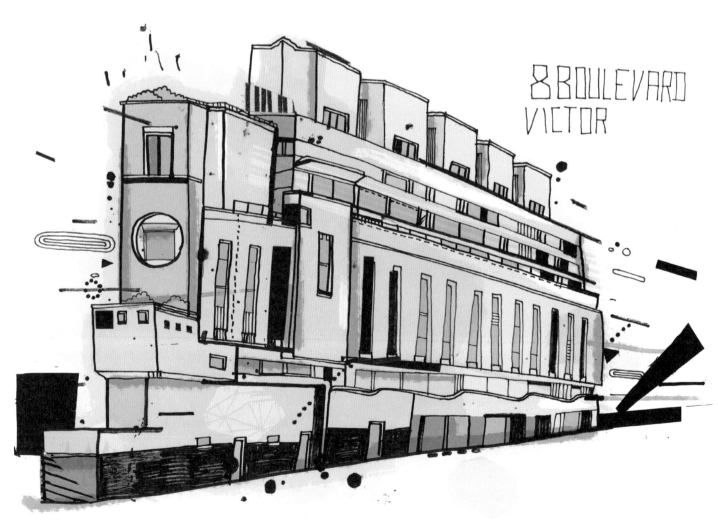

8 BOULEVARD VICTOR

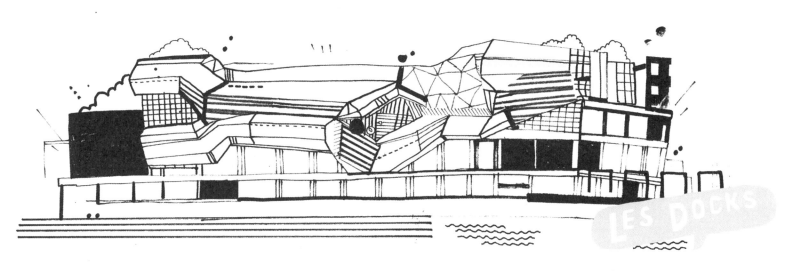

LES DOCKS

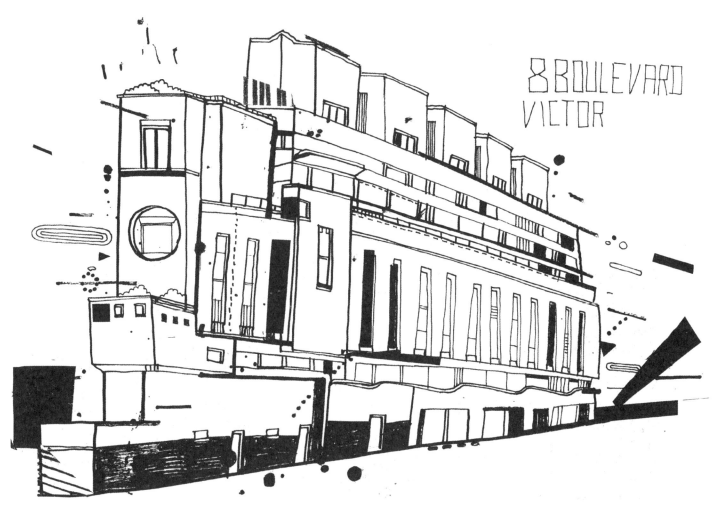

8 BOULEVARD VICTOR

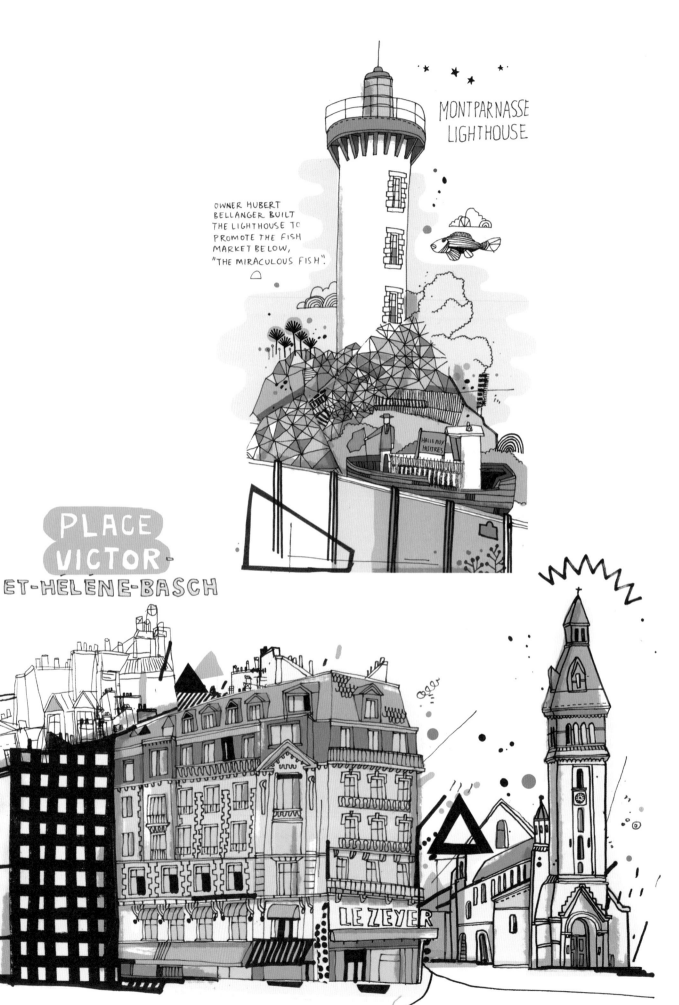

MONTPARNASSE LIGHTHOUSE

OWNER HUBERT BELLANGER BUILT THE LIGHTHOUSE TO PROMOTE THE FISH MARKET BELOW, "THE MIRACULOUS FISH".

HALLE AUX HUITRES

PLACE VICTOR-ET-HÉLÈNE-BASCH

LE ZEYER

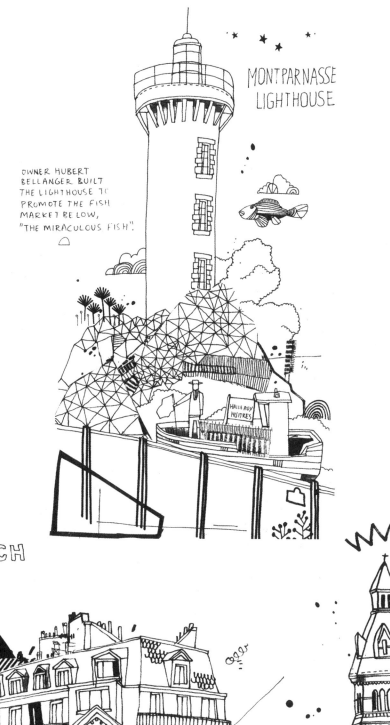

MONTPARNASSE LIGHTHOUSE

OWNER HUBERT
BELLANGER BUILT
THE LIGHTHOUSE TO
PROMOTE THE FISH
MARKET BELOW,
"THE MIRACULOUS FISH".

PLACE
VICTOR-
ET-HÉLÈNE-BASCH

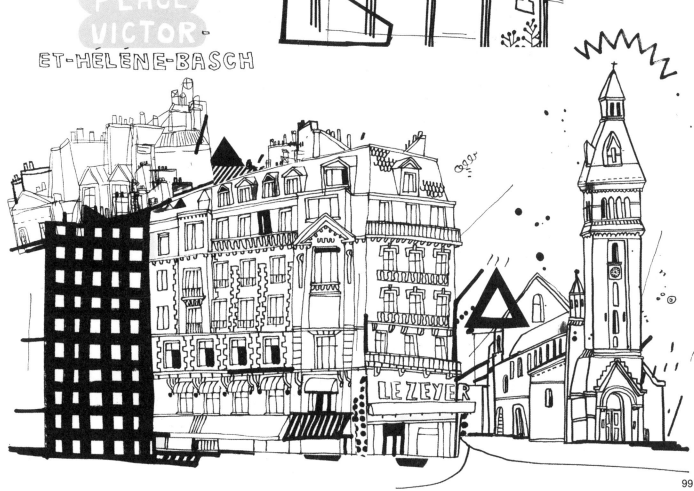

LE ZEYER

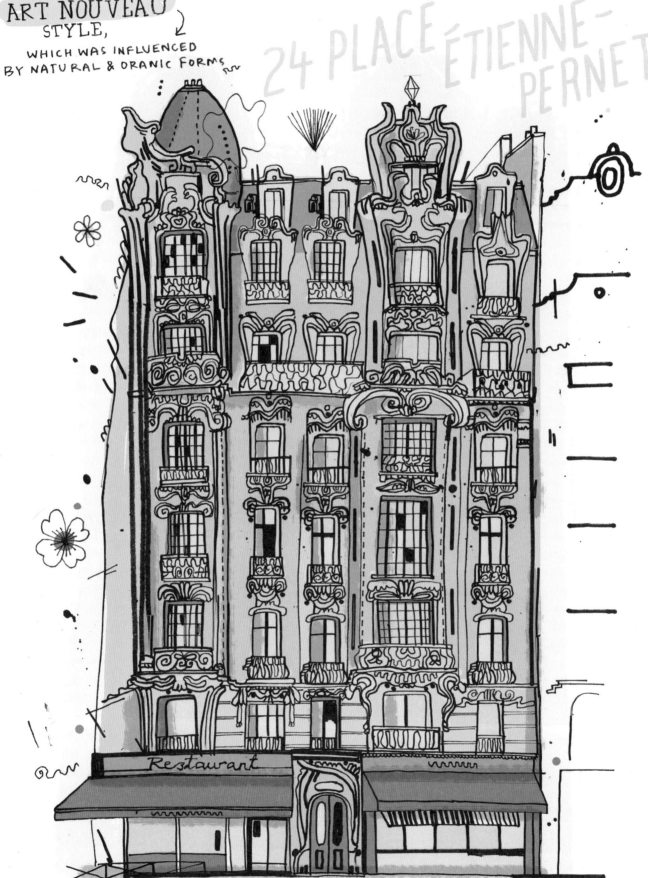

DESIGNED IN THE **ART NOUVEAU** STYLE, WHICH WAS INFLUENCED BY NATURAL & ORANIC FORMS

24 PLACE ÉTIENNE-PERNET

Restaurant

DESIGNED IN THE
**ART NOUVEAU**
STYLE,
WHICH WAS INFLUENCED
BY NATURAL & ORANIC FORMS

24 PLACE ÉTIENNE-PERNET

Restaurant

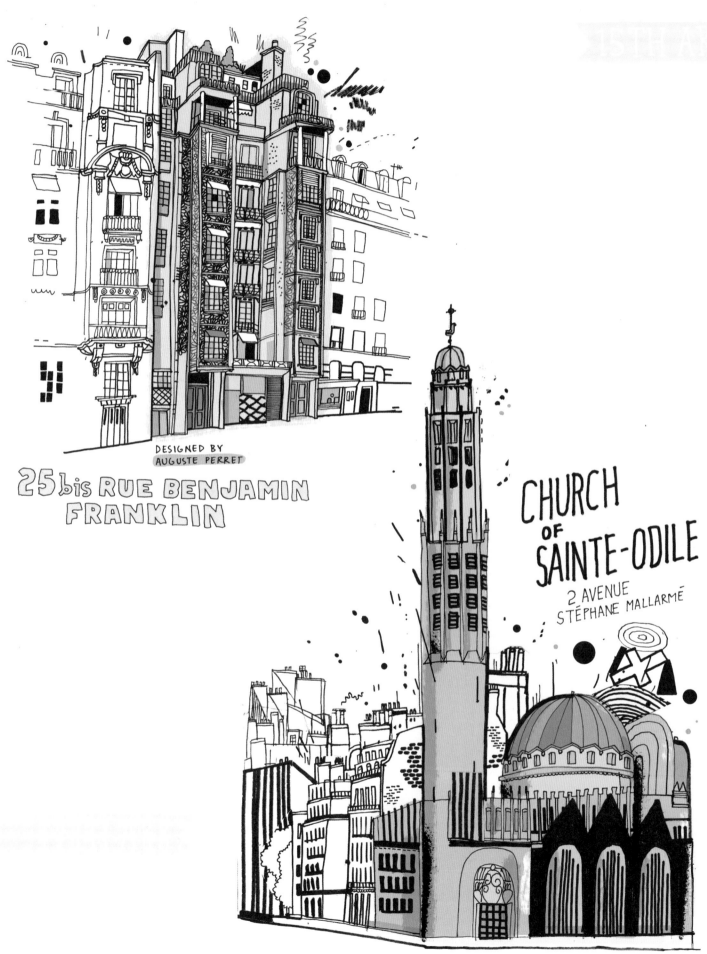

DESIGNED BY
AUGUSTE PERRET

25 bis RUE BENJAMIN FRANKLIN

CHURCH OF SAINTE-ODILE
2 AVENUE STÉPHANE MALLARMÉ

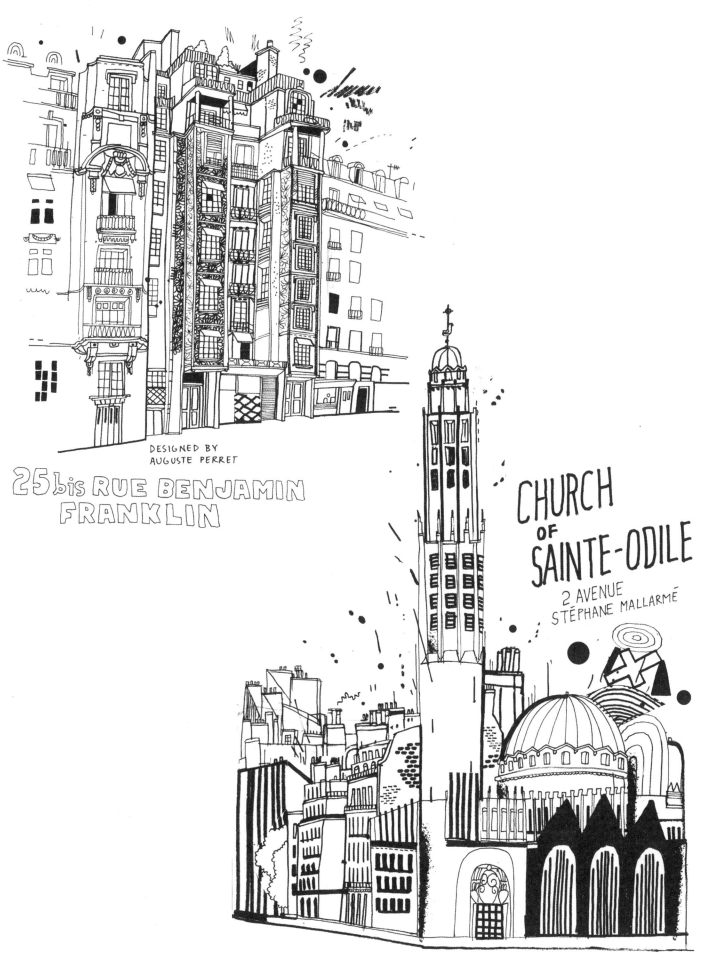

DESIGNED BY
AUGUSTE PERRET

25bis RUE BENJAMIN
FRANKLIN

CHURCH
OF
SAINTE-ODILE
2 AVENUE
STÉPHANE MALLARMÉ

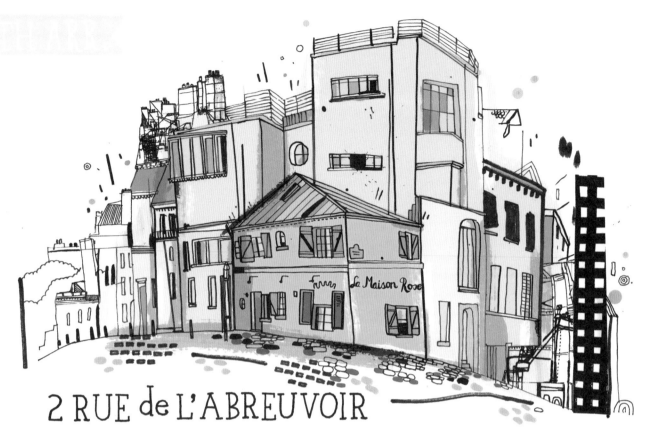

# 2 RUE de L'ABREUVOIR

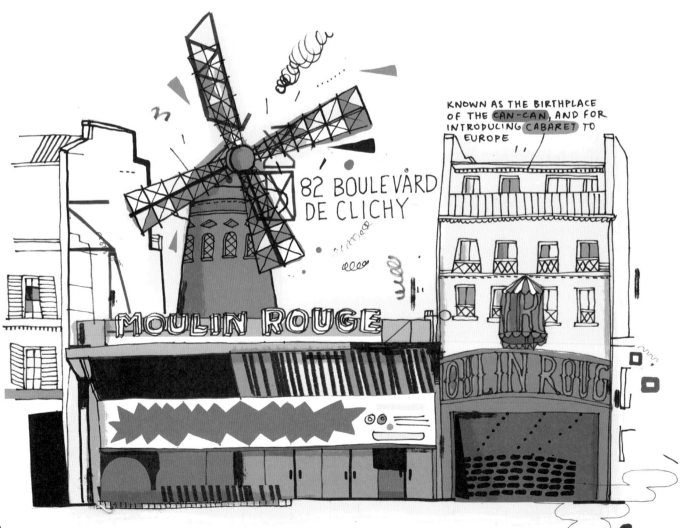

82 BOULEVARD DE CLICHY

KNOWN AS THE BIRTHPLACE OF THE CAN-CAN, AND FOR INTRODUCING CABARET TO EUROPE

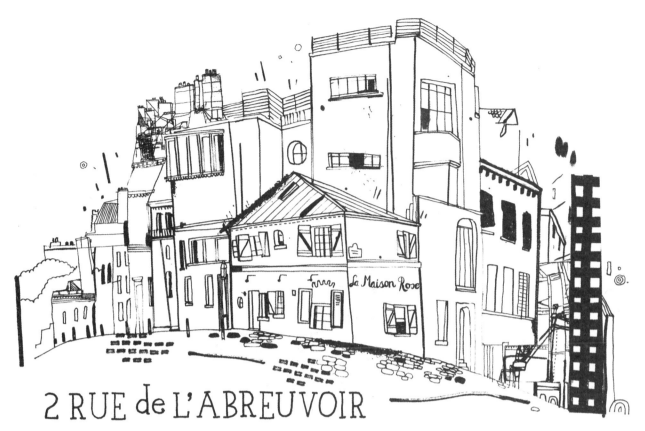

2 RUE de L'ABREUVOIR

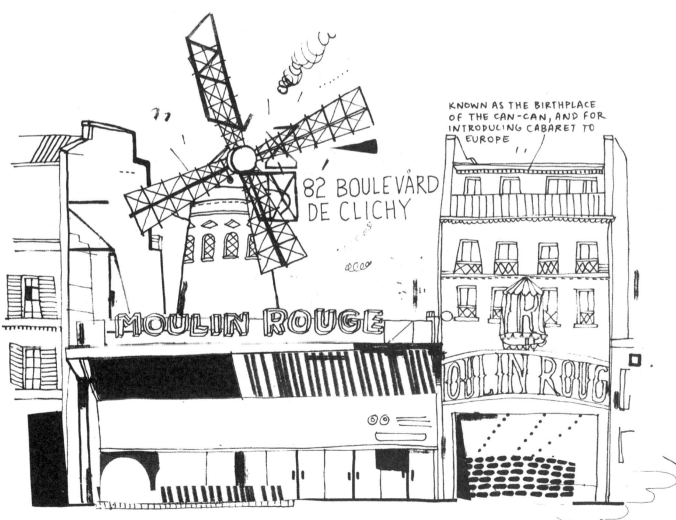

82 BOULEVARD DE CLICHY

KNOWN AS THE BIRTHPLACE OF THE CAN-CAN, AND FOR INTRODUCING CABARET TO EUROPE

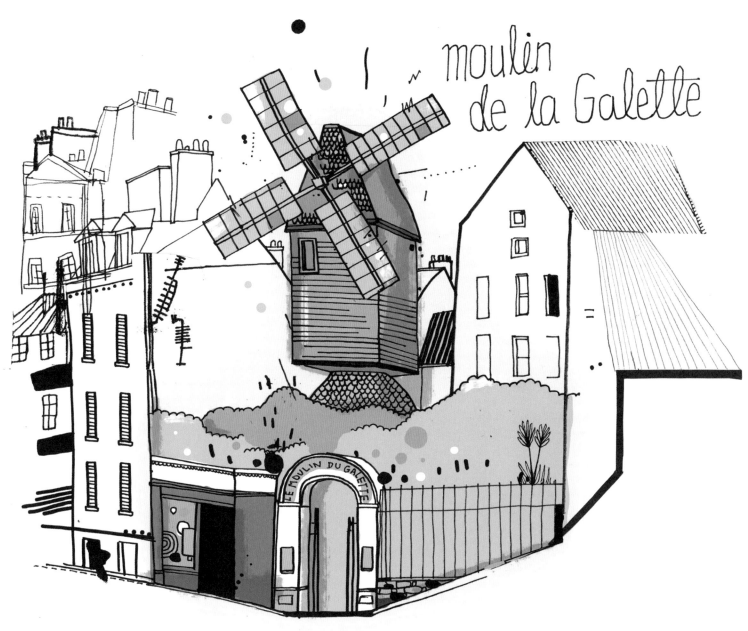

moulin
de la Galette

ALSO KNOWN AS BLUTE FIN
IT WAS BUILT IN 1622

IMMORTALIZED IN RENOIR'S.
PAINTING *BAL DU MOULIN DE
LA GALETTE*

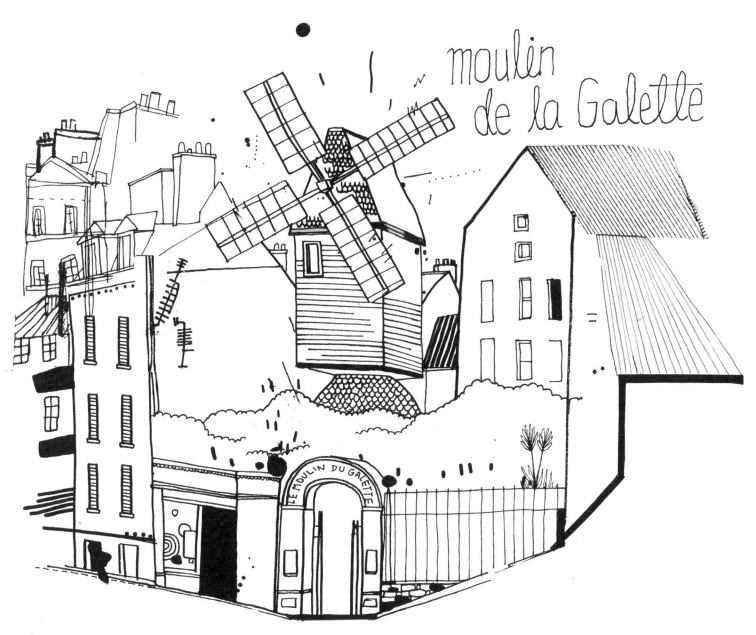

moulin de la Galette

ALSO KNOWN AS BLUTE FIN
IT WAS BUILT IN 1622

IMMORTALIZED IN RENOIR'S
PAINTING *BAI DU MOULIN DE
LA GALETTE*

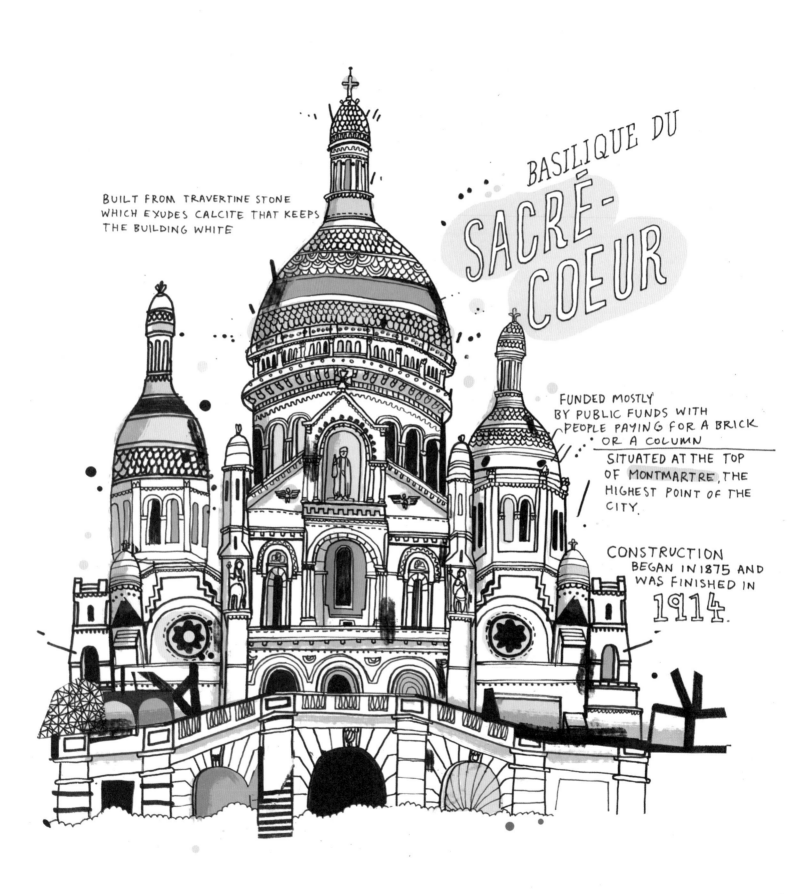

BUILT FROM TRAVERTINE STONE
WHICH EXUDES CALCITE THAT KEEPS
THE BUILDING WHITE

BASILIQUE DU
SACRÉ-
COEUR

FUNDED MOSTLY
BY PUBLIC FUNDS WITH
PEOPLE PAYING FOR A BRICK
OR A COLUMN

SITUATED AT THE TOP
OF MONTMARTRE, THE
HIGHEST POINT OF THE
CITY.

CONSTRUCTION
BEGAN IN 1875 AND
WAS FINISHED IN
1914.

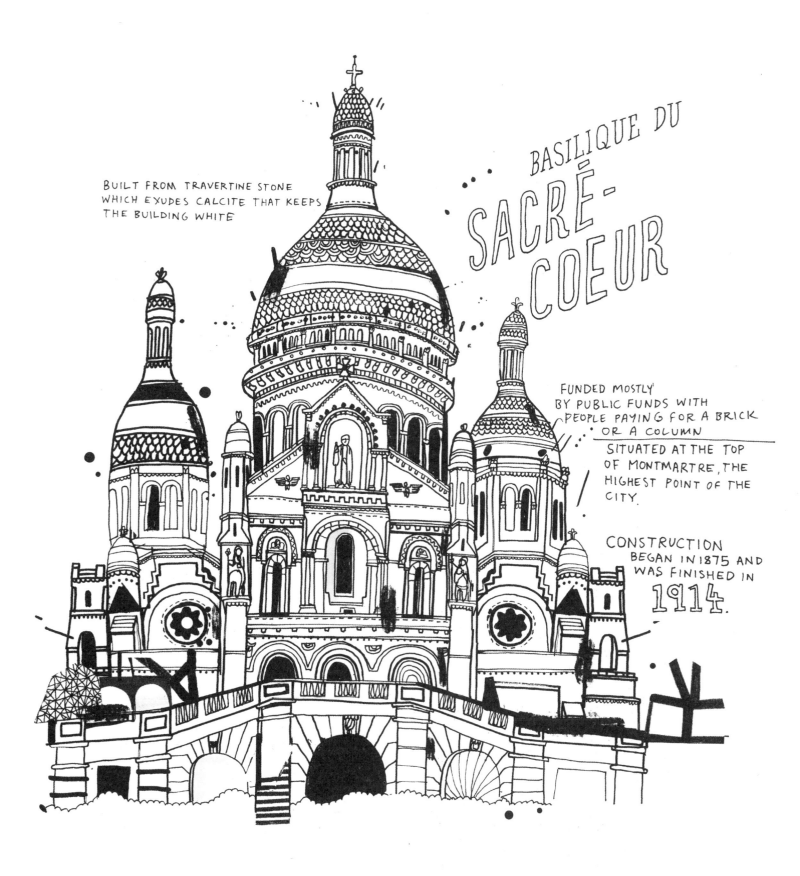

BASILIQUE DU
SACRÉ-
COEUR

BUILT FROM TRAVERTINE STONE
WHICH EXUDES CALCITE THAT KEEPS
THE BUILDING WHITE

FUNDED MOSTLY
BY PUBLIC FUNDS WITH
PEOPLE PAYING FOR A BRICK
OR A COLUMN

SITUATED AT THE TOP
OF MONTMARTRE, THE
HIGHEST POINT OF THE
CITY.

CONSTRUCTION
BEGAN IN 1875 AND
WAS FINISHED IN
1914.

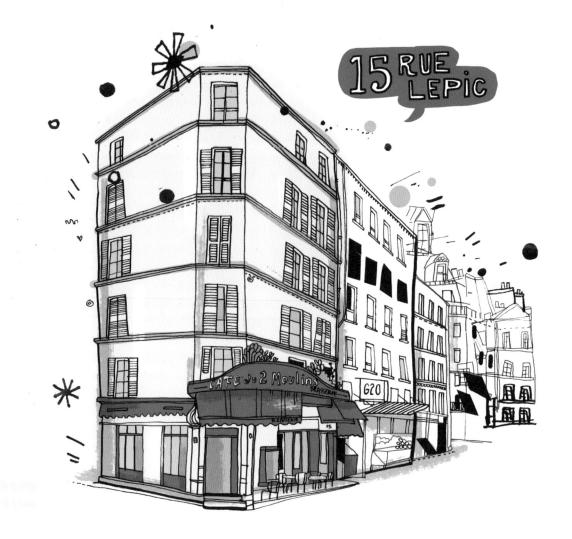

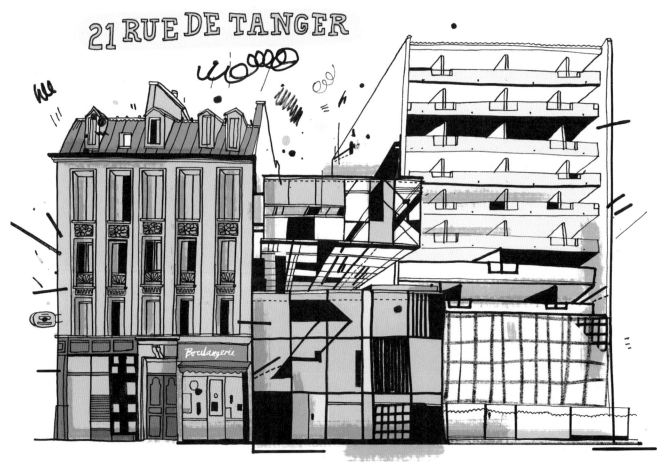

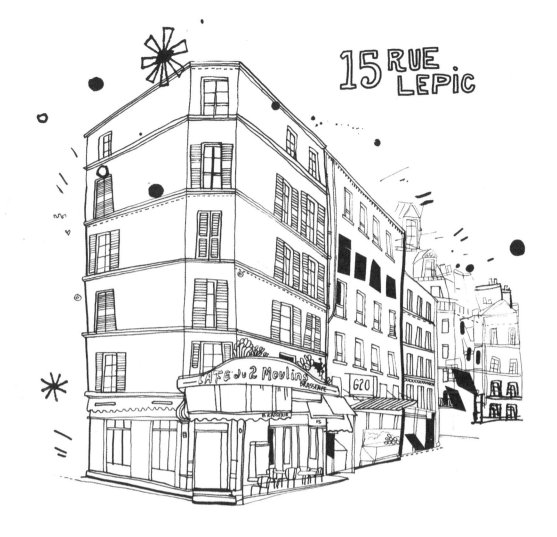

15 RUE LEPIC

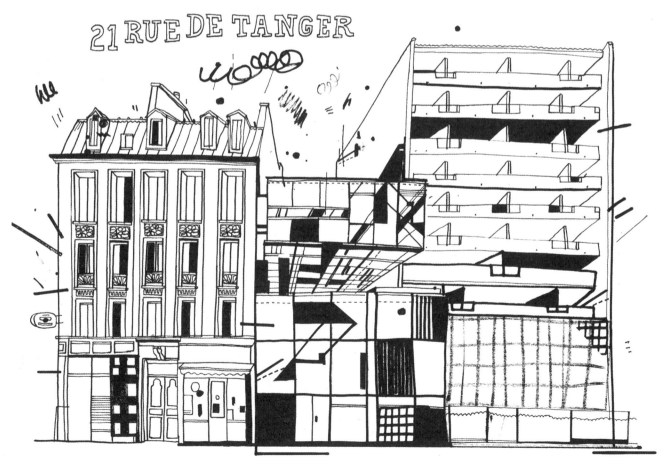

21 RUE DE TANGER

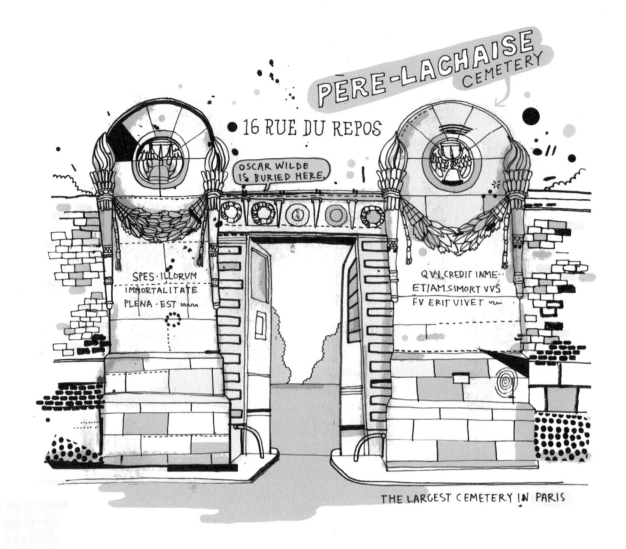

PÈRE-LACHAISE CEMETERY

16 RUE DU REPOS

OSCAR WILDE IS BURIED HERE.

SPES · ILLORVM
IMMORTALITATE
PLENA · EST

QVI · CREDIT INME ·
ET IAM SIMORT VVS
FV ERIT VIVET

THE LARGEST CEMETERY IN PARIS

LES ARÈNES DE PICASSO

AT NOISY-LE-GRAND

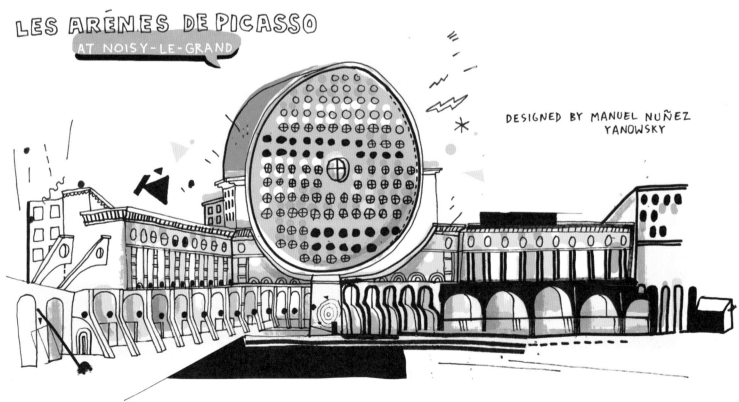

DESIGNED BY MANUEL NUÑEZ YANOWSKY

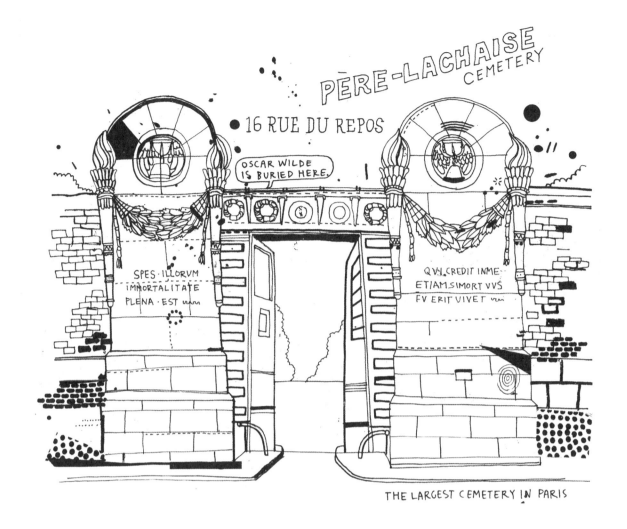

PÈRE-LACHAISE CEMETERY

16 RUE DU REPOS

OSCAR WILDE IS BURIED HERE.

SPES · ILLORVM
IMMORTALITATE
PLENA · EST

QVI · CREDIT IN ME ·
ETIAM SI MORTVVS
FV ERIT VIVET

THE LARGEST CEMETERY IN PARIS

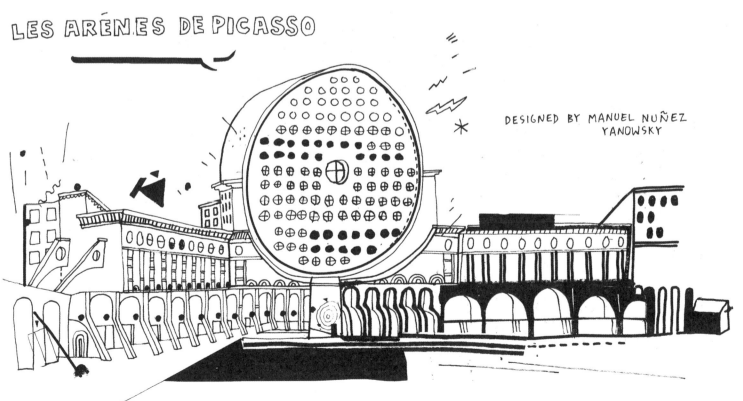

LES ARÉNES DE PICASSO

DESIGNED BY MANUEL NUÑEZ YANOWSKY

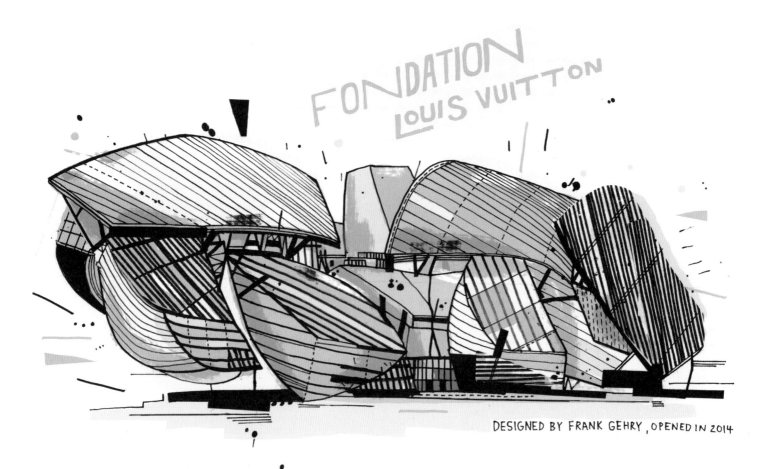

FONDATION LOUIS VUITTON

DESIGNED BY FRANK GEHRY, OPENED IN 2014

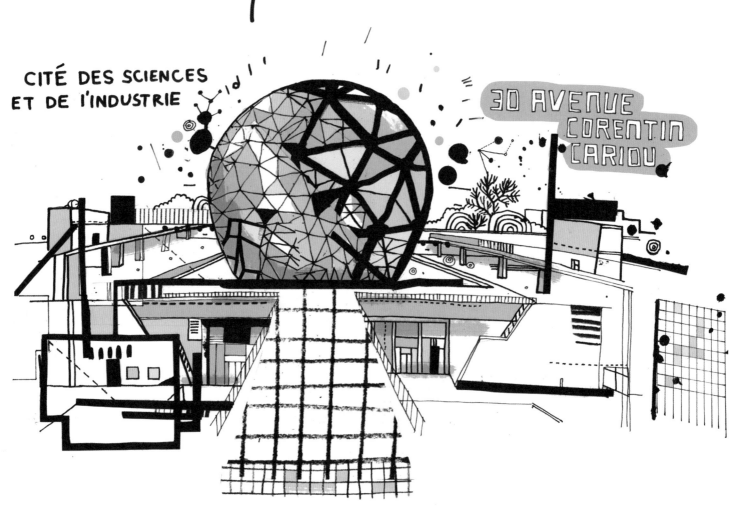

CITÉ DES SCIENCES ET DE l'INDUSTRIE

30 AVENUE CORENTIN CARIOU

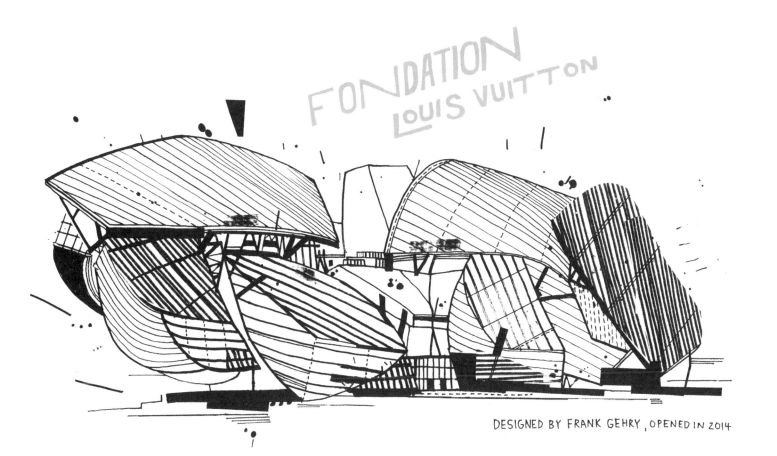

FONDATION LOUIS VUITTON

DESIGNED BY FRANK GEHRY, OPENED IN 2014

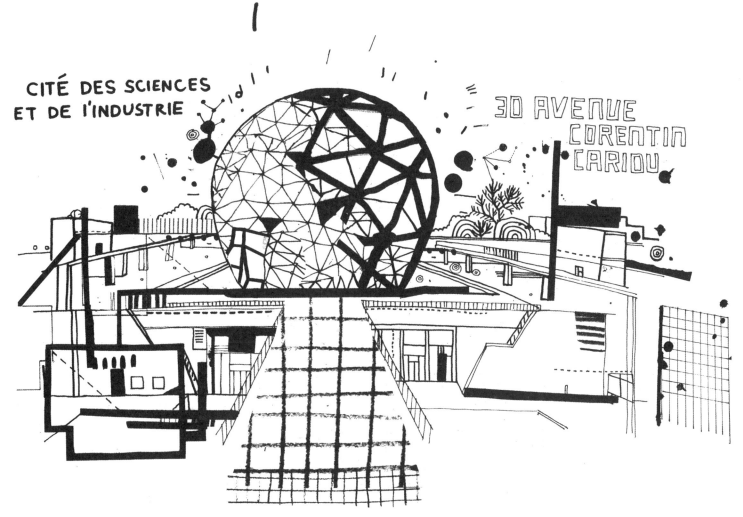

CITÉ DES SCIENCES
ET DE l'INDUSTRIE

30 AVENUE CORENTIN CARIOU

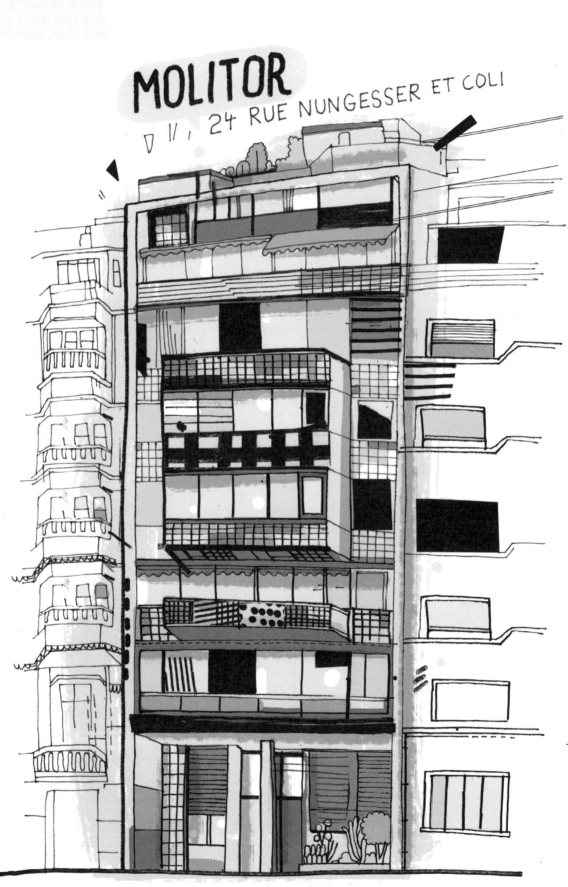

MOLITOR

11, 24 RUE NUNGESSER ET COLI

DESIGNED BY LE CORBUSIER

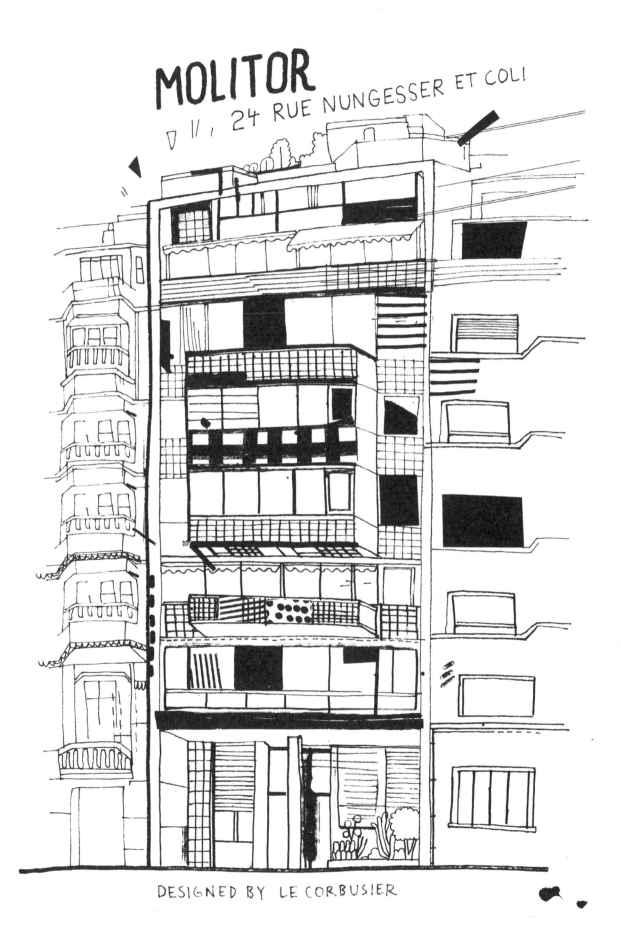

# MOLITOR
## 24 RUE NUNGESSER ET COLI

DESIGNED BY LE CORBUSIER

# LA GRANDE ARCHE
# DE LA DÉFENSE

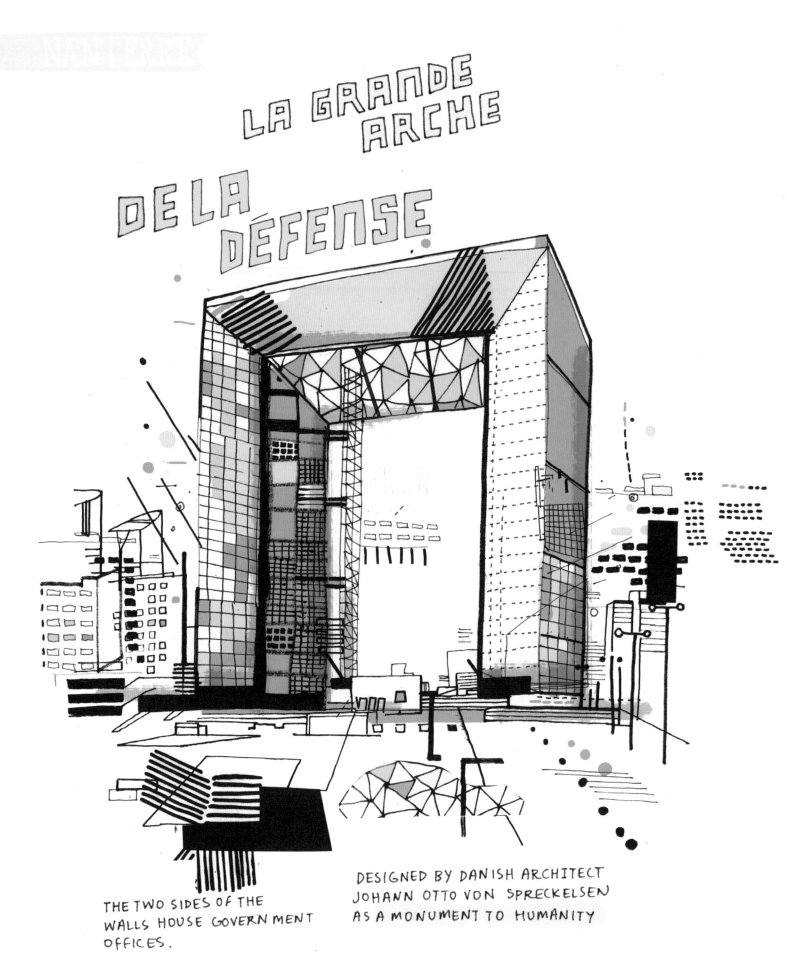

THE TWO SIDES OF THE
WALLS HOUSE GOVERNMENT
OFFICES.

DESIGNED BY DANISH ARCHITECT
JOHANN OTTO VON SPRECKELSEN
AS A MONUMENT TO HUMANITY

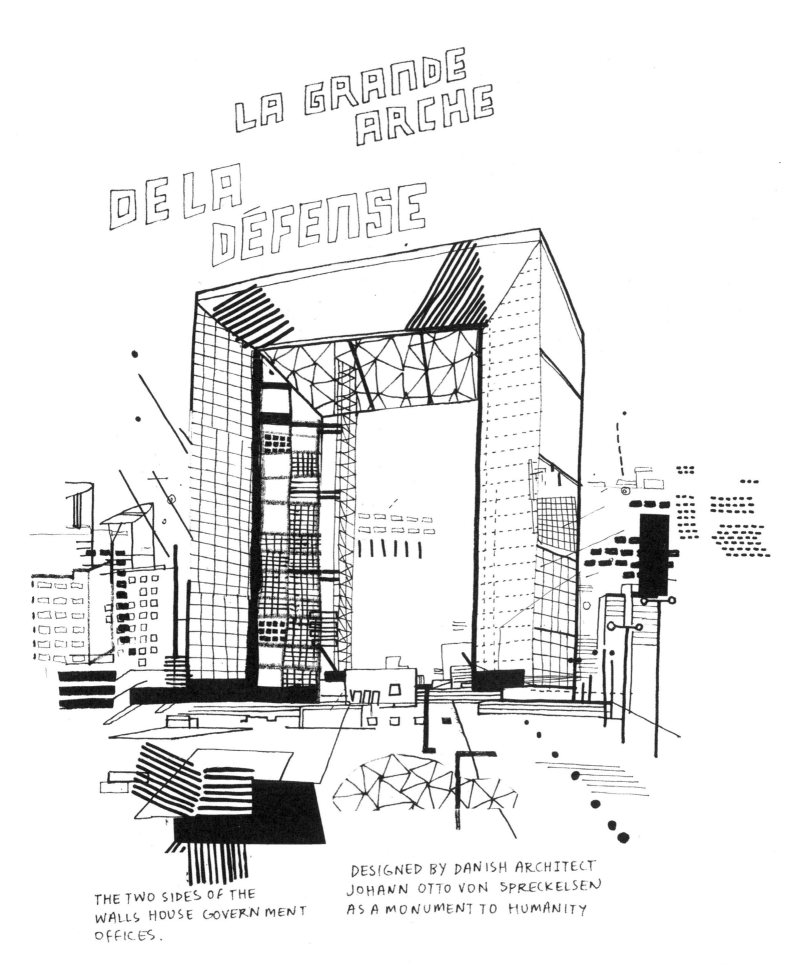

# LA GRANDE ARCHE

## DE LA DÉFENSE

THE TWO SIDES OF THE
WALLS HOUSE GOVERNMENT
OFFICES.

DESIGNED BY DANISH ARCHITECT
JOHANN OTTO VON SPRECKELSEN
AS A MONUMENT TO HUMANITY

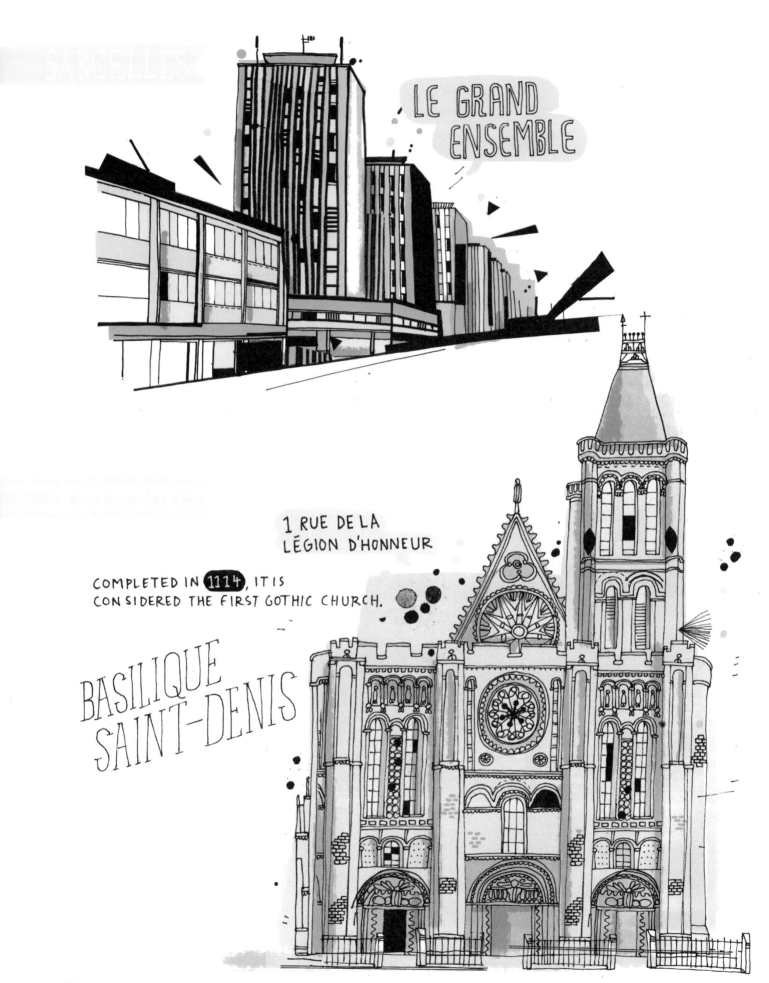

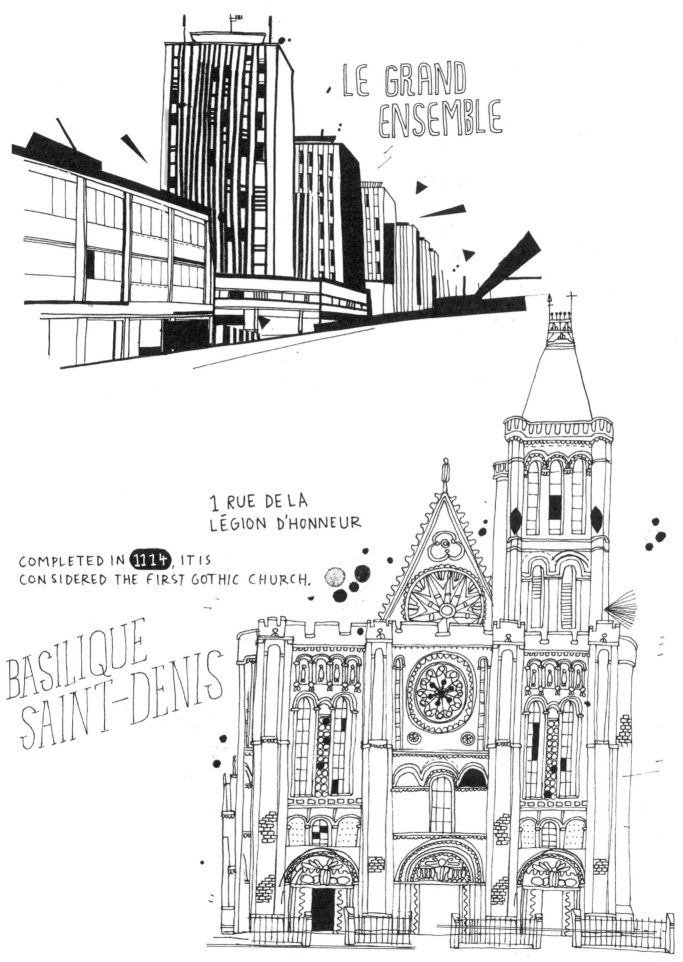

LE GRAND
ENSEMBLE

1 RUE DE LA
LÉGION D'HONNEUR

COMPLETED IN 1114, IT IS
CONSIDERED THE FIRST GOTHIC CHURCH.

BASILIQUE
SAINT-DENIS

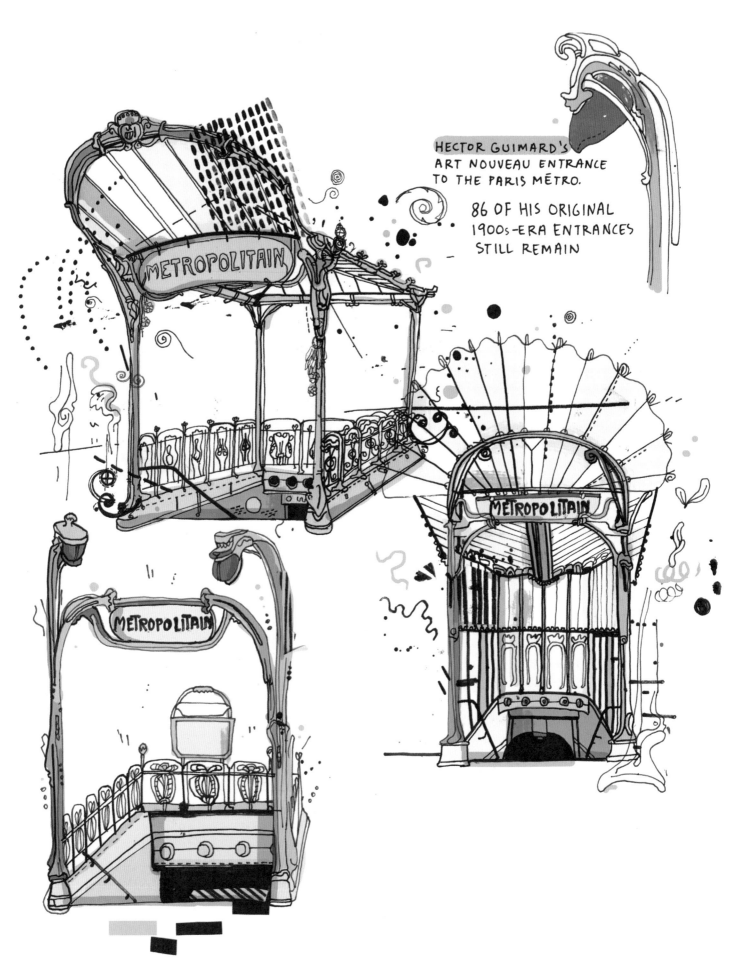

HECTOR GUIMARD'S
ART NOUVEAU ENTRANCE
TO THE PARIS MÉTRO.

86 OF HIS ORIGINAL
1900s-ERA ENTRANCES
STILL REMAIN

METROPOLITAIN

METROPOLITAIN

METROPOLITAIN

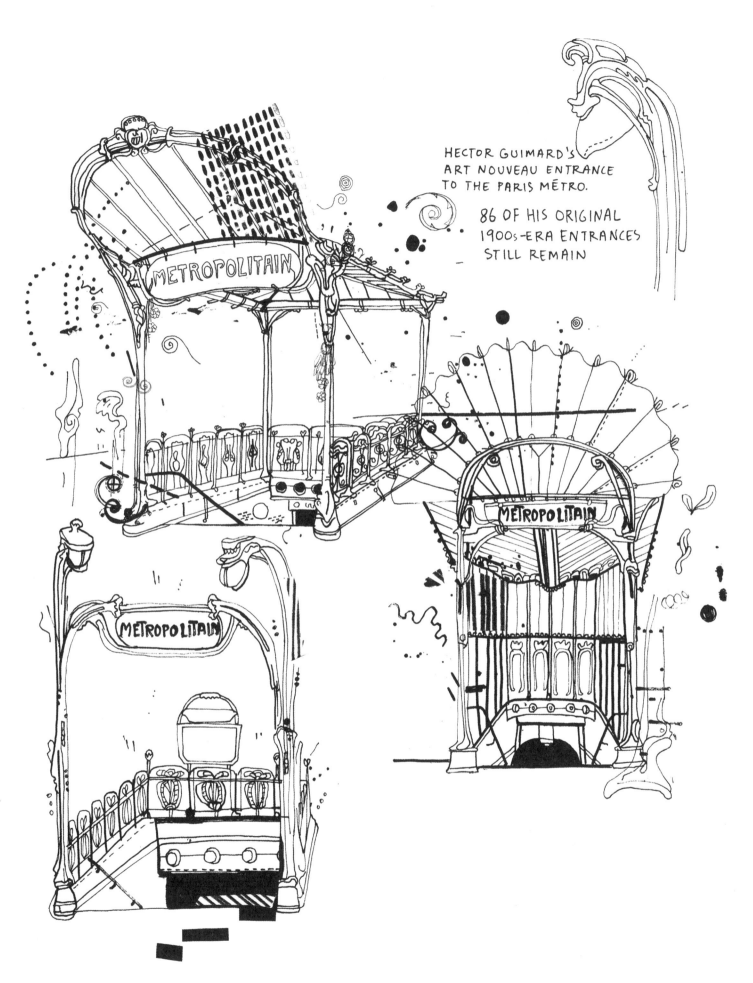

HECTOR GUIMARD'S
ART NOUVEAU ENTRANCE
TO THE PARIS MÉTRO.

86 OF HIS ORIGINAL
1900s-ERA ENTRANCES
STILL REMAIN

METROPOLITAIN

METROPOLITAIN

METROPOLITAIN

초판 1쇄 발행 2018년 08월 05일

지은이 | 제임스 걸리버 핸콕
옮긴이 | 김문주
발행인 | 홍경숙
발행처 | 책발전소

경영총괄 | 안경찬
기획편집 | 김효단

출판등록 | 2008년 5월 2일 제2008-000221호
주소 | 서울 마포구 토정로 222, 201호 (한국출판콘텐츠센터)
주문전화 | 02-325-8901

표지 디자인 | 김종민
본문 디자인 | 김종민
지업사 | 월드페이퍼
인쇄 | 영신문화사

ISBN 978-89-94747-19-4 14650

* 책발전소는 위너스북의 실용 · 인문 브랜드입니다.
* 책값은 뒤표지에 있습니다.
* 잘못된 책이나 파손된 책은 구입하신 서점에서 교환해 드립니다.
* 위너스북에서는 출판을 원하시는 분, 좋은 출판 아이디어를 갖고 계신 분들의 문의를 기다리고 있습니다.
winnersbook@naver.com | Tel 02)325-8901

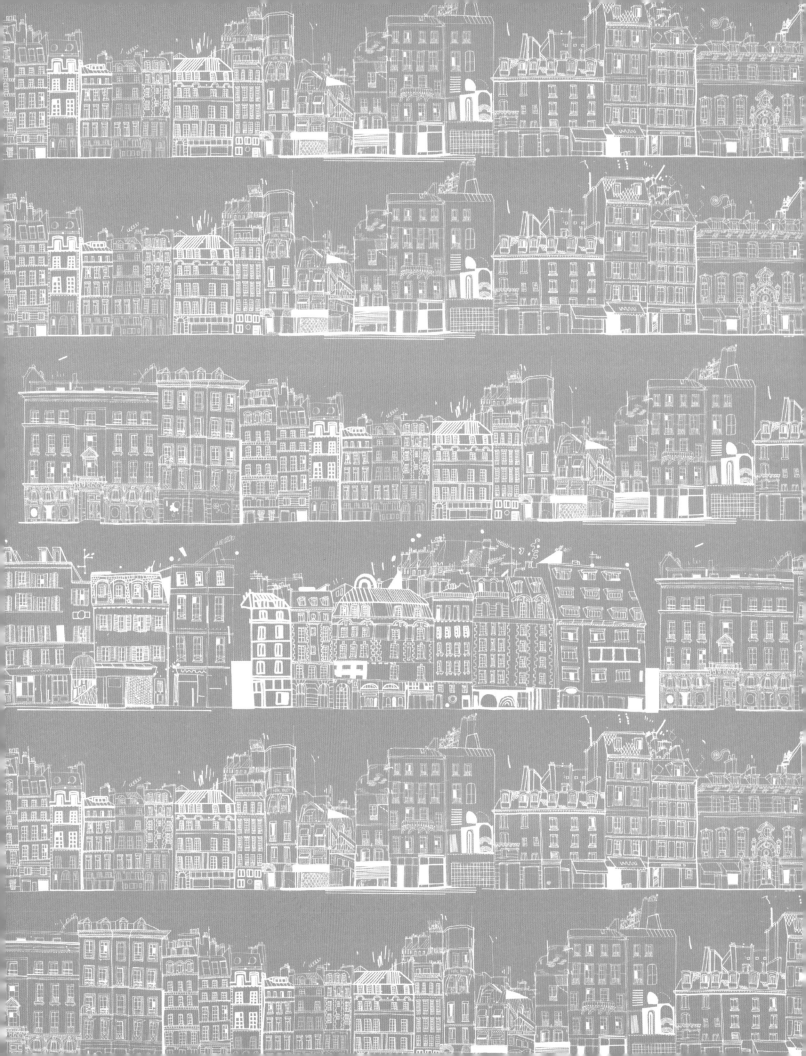